The Figure in Motion

The Figure in Motion

WATSON-GUPTILL PUBLICATIONS/NEW YORK

ACKNOWLEDGMENTS

A deep sense of gratitude fills my heart when I think of the constant support and assistance given me by my wife, Shelly. The making of this book could not have been done without her. I would also like to thank Mary Suffudy. Her guidance through the difficult process of publishing has been invaluable.

Thomas Easley enjoys an international reputation as one of the world's foremost miniature painters. His works are in many collections around the world, among them those of H.R.H. The Prince of Wales and Arrigo Cipriani, owner, Harry's Bar, Venice. He lives in Poughkeepsie, New York.

Mark Smith's photographs have been featured in many prestigious publications, including *The New York Times*, for which he was the northern Italy photographer, as well as books on architecture. Well known for his portraits, he is also the author of *The Nude Figure*. Smith lives in Venice, Italy.

First published 1986 in New York by Watson-Guptill Publications, a division of Billboard Publications, Inc., 1515 Broadway, New York, N.Y. 10036

The Library of Congress has catalogued the hardcover edition of this book as follows:
Easley, Thomas.
 The figure in motion.
 1. Photography of the nude. 2. Human figure in art.
3. Models, Artists'. I. Smith, Mark (Mark E.)
II. Title.
TR675.E25 1986 779'.21 86-19063
 CIP
ISBN: 0-8230-1692-7

Distributed in the United Kingdom by Phaidon Press, Ltd., Littlegate House, St. Ebbe's St., Oxford

ISBN (paperback) 0-8230-1691-9

Printed in U.S.A.

First paperback printing, 2000

1 2 3 4 5 6 7 8 9/08 07 06 05 04 03 02 01 00

Contents

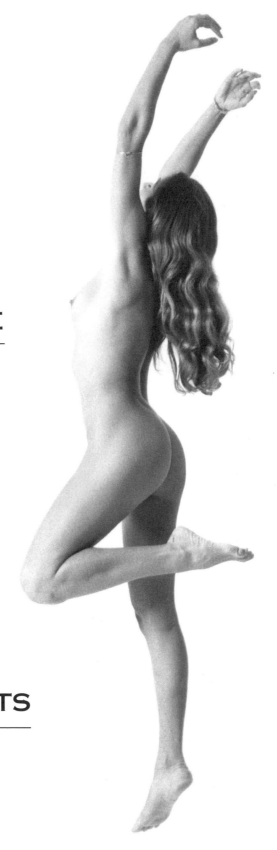

Introduction

Though artists must learn to see before they learn to draw, they do not necessarily draw what they see. Most artists use what they see as an inspiration to draw, paint, or sculpt what they feel. Traditionally, nothing has been of more interest to the artist, or has been considered more beautiful, than the human figure. And artists have always been intrigued with how the body moves.

This book was made with artists of every level in mind. The art student, whose study of the body has just begun, can develop a positive relationship between eye and hand by making free-hand copies of parts of the figure, positions, and combinations of positions from this book. Soon, he or she will become more aware of the great subtleties of the body and how the slightest change in light, movement, and expression affects the whole composition.

The Figure in Motion is intended to supplement an artist's life drawing studies, and to be used as a reference when a model is not available. The book also provides the artist with poses not seen in the life class—simply because a model cannot hold many of the poses. With this book, you can practice at home and experiment. Making exact copies of the pictures will increase confidence and doing quick three-minute sketches will improve your drawing speed and accuracy. I suggest that when you work with this book you try to put yourself into the spirit of the model's pose. Try to imagine what the model feels. Let yourself experience the weight of the body, the energy expended through the pose.

The poses in this book can also be used to spur the imagination. How would a leaping figure look, for example, if you turned the picture upside down? I have actually rotated a number of the

photographs 360 degrees. The result was a delightful source of reference for arms and legs seen from many different angles and positions. Since *The Figure in Motion* is a book about seeing, the figures are printed one or two per page—large enough to work easily from. Smaller photographs often conceal basic body structure, gesture, line, and expression.

The photographs in this book were chosen on the basis of their overall aesthetic quality. Each pose is intended to encompass the past, or origin of the movement; the present as captured in the photograph; and the future, where the movement is leading. What inspired this movement? What thought or impulse was behind it? What feeling is now expressed? These are questions we asked, and that we hope you will ask as you look at and study the photographs.

In creating this book, Mark Smith and I tested thirty models over a period of eighteen months. Out of ten thousand shots we selected about two hundred positions that met our aesthetic criteria. The poses were then divided into front, left side, three-quarter front and back, right side, and back. The book has been designed so that the poses move from center, to left, to back, to right, and again to front.

Because the front view of the body is the most intimate, it is particularly subject to suggestive interpretation; these poses required more time and consideration than did other positions. The left, three-quarter, and right positions are frequently more dramatic, and in a sense more athletic, positions that I would call easy to see. The three-quarter view, because of the added complication of foreshortening, provides good exercise for the more advanced artist. As with the three-quarter angle in portrait work, a likeness from this view is more difficult to capture.

Lighting was an important consideration in planning these poses. It is the intensity, direction, and placement of light that creates the sense of movement. The brighter and more concentrated the light on a given object, the more dramatic the action of that object becomes. Light as interpreted by the observer suggests movement, and in this sense light could be called the voice of the visual image. Light connects the various parts of a subject. When communciation between these parts is clearly stated, I believe a work of art begins to breathe.

Our primary aim in lighting the models was to capture the tone of the body as influenced by the underlying muscles. We knew that too much or too little light would obscure detail. In some of the photographs the primary souce of light comes from the front of the figure; in others the primary light source is from the side. Our objective was to present as much of the figure as possible, and we wanted a sense of neutrality in the lighting so that the drama created by the action of the body would not be overwhelmed. We have included some photographs with black backgrounds that illustrate how light—or the absence of light—can radically influence the way a subject is perceived. With each work the artist must ask, "What do I wish to say? What can I say?" then choose the light needed to say it. Each of the artists whose work appears in the book has a distinct drawing style. These drawings have been included because they show that there are no absolute rules about drawing the body, and to encourage experimentation with different styles and techniques.

The Figure in Motion is not an attempt to systematically catalog the many positions into which the human body can move. Rather it is a visualistic guide to body motion and compositional possibilities. It arose out of my own need to have quick and lasting reference to positions that are difficult or impossible to hold, and it is my sincere hope that *The Figure in Motion* book will benefit serious artists of every level. ●

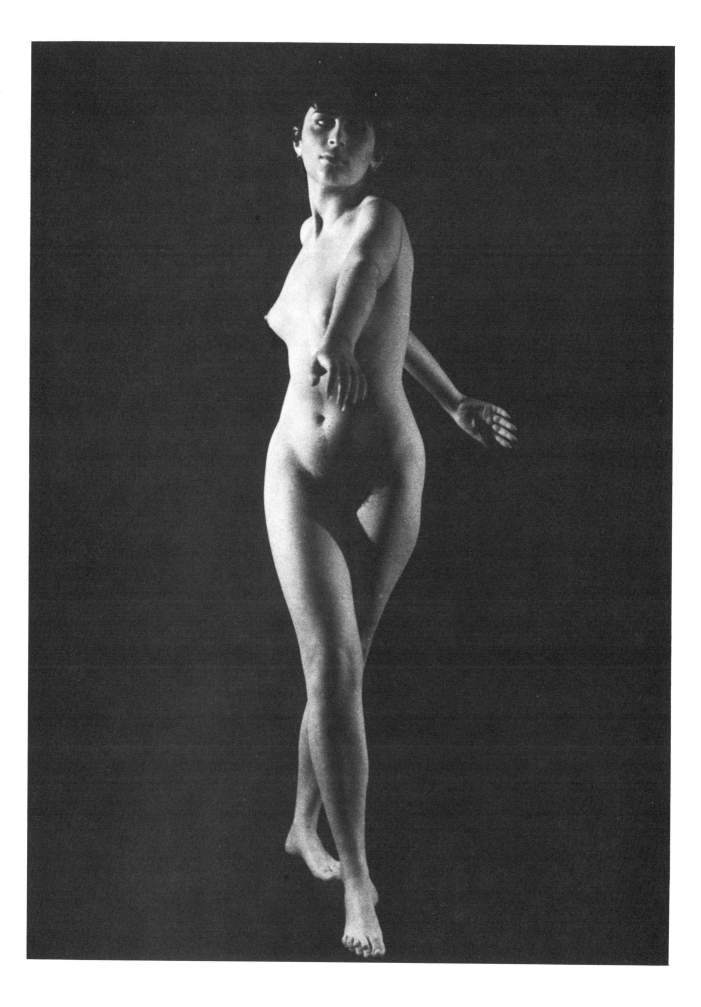

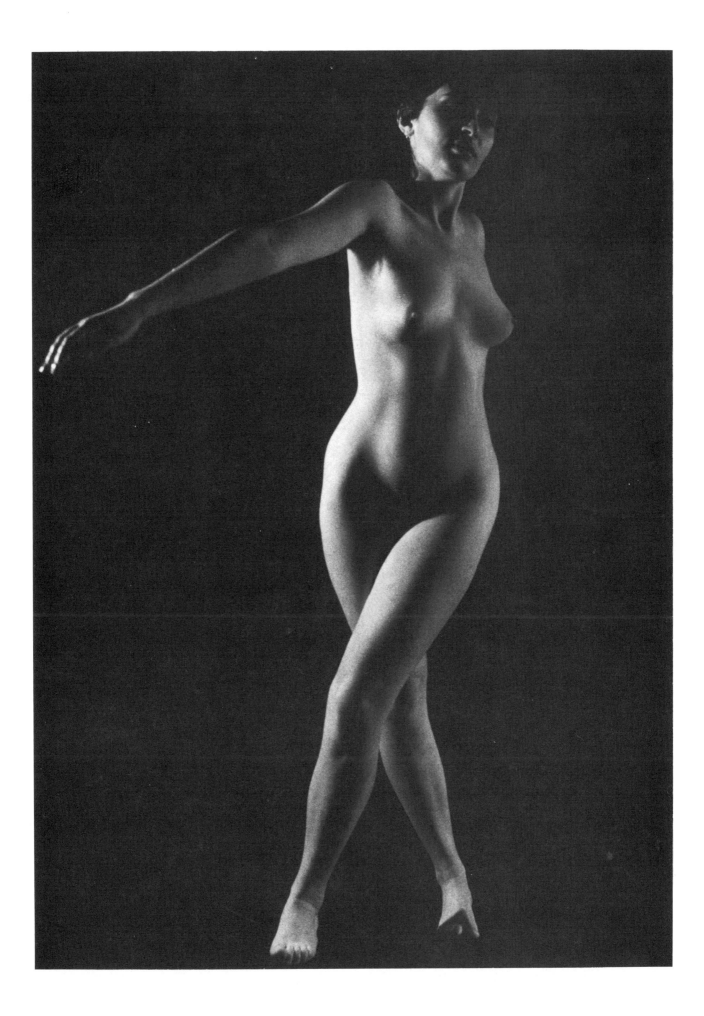

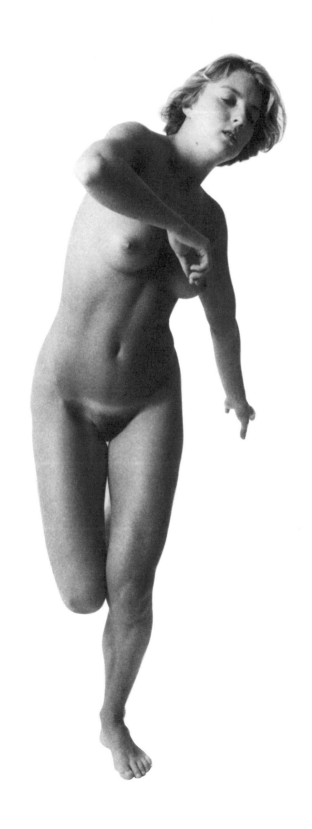

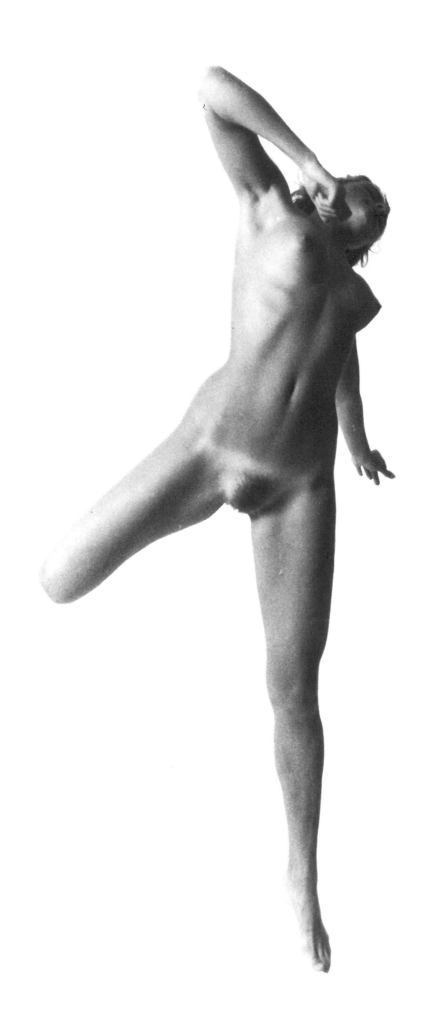

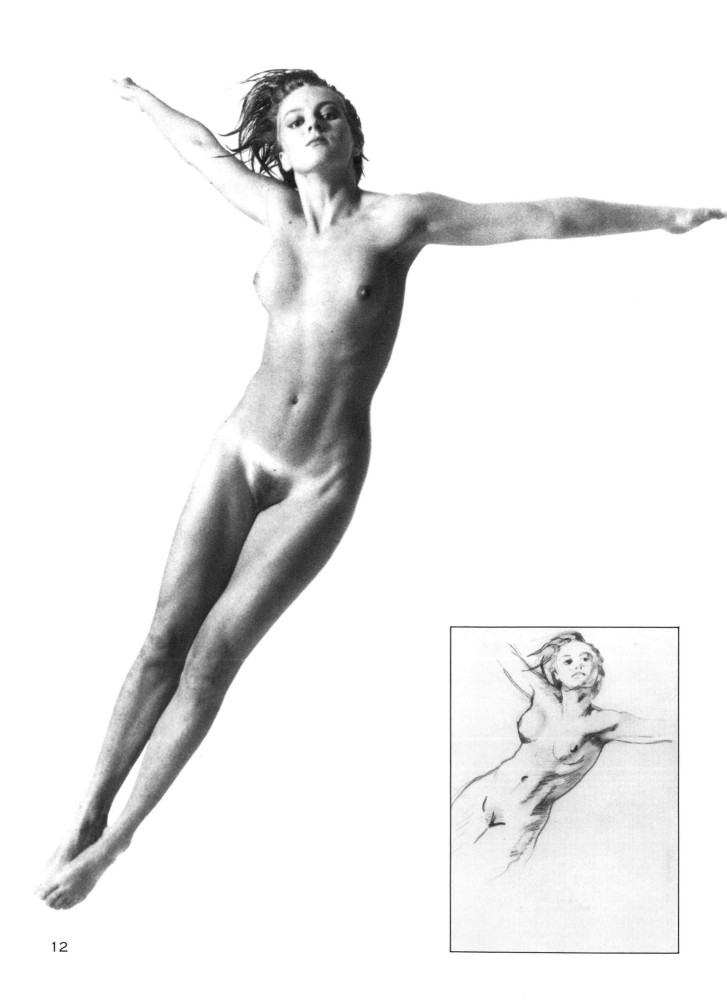

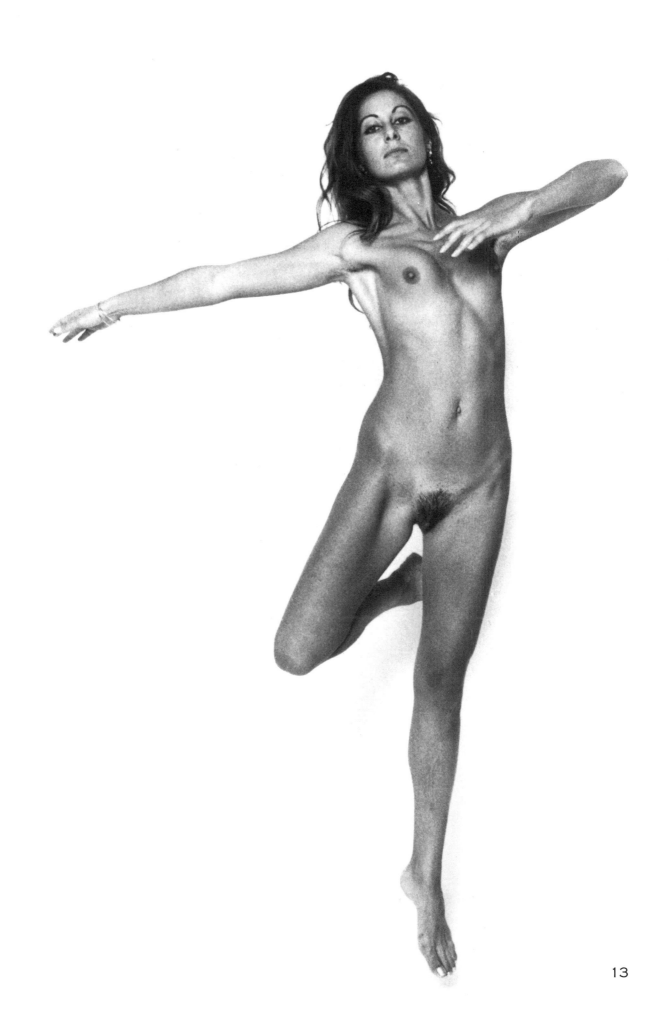

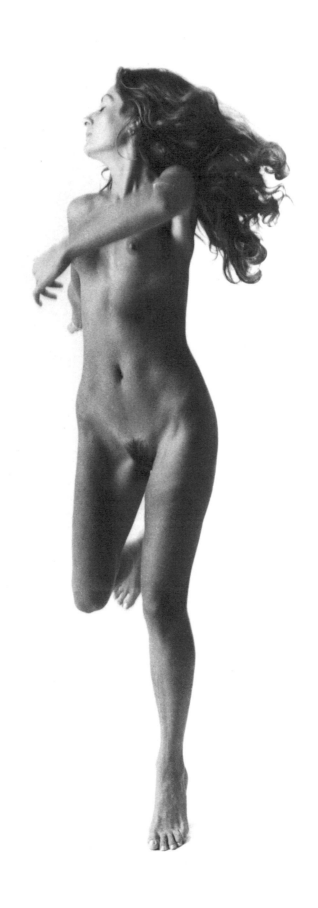

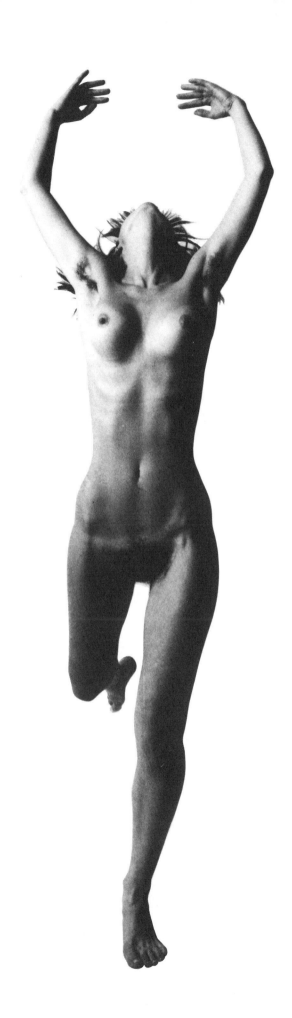
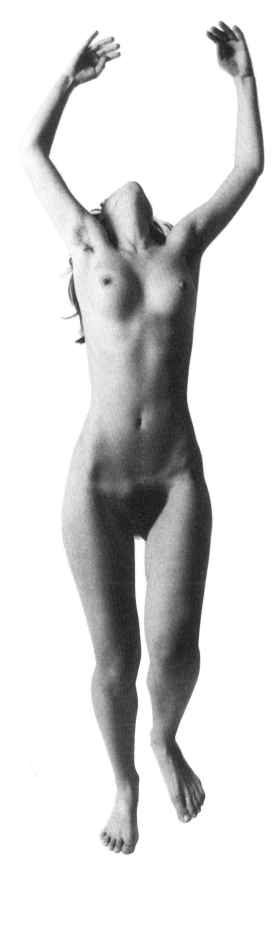

15

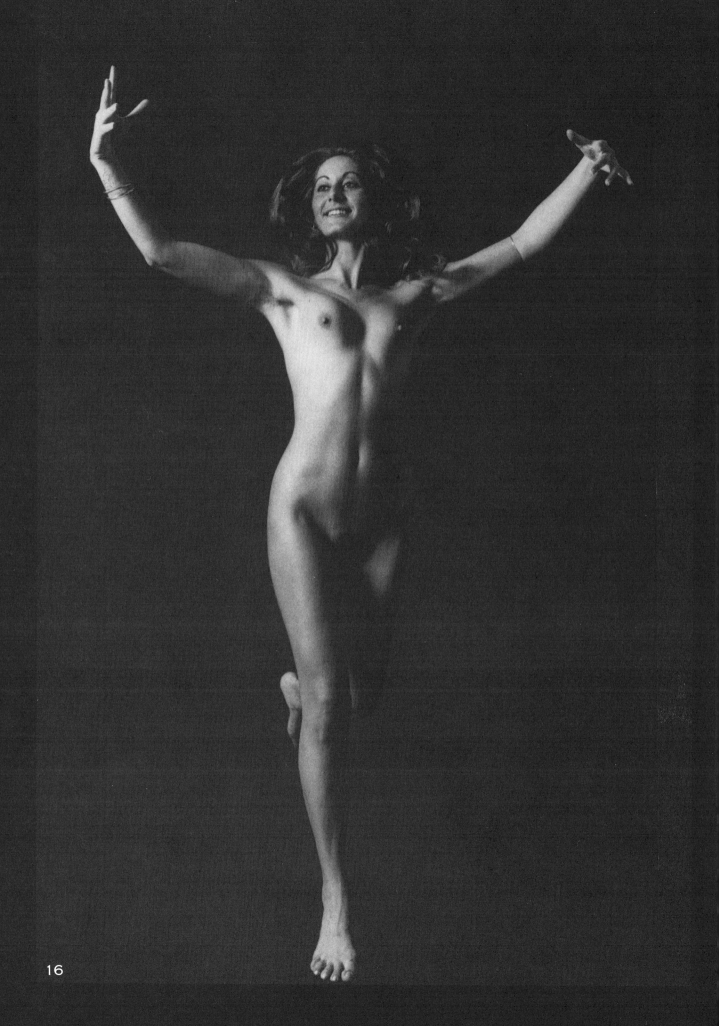

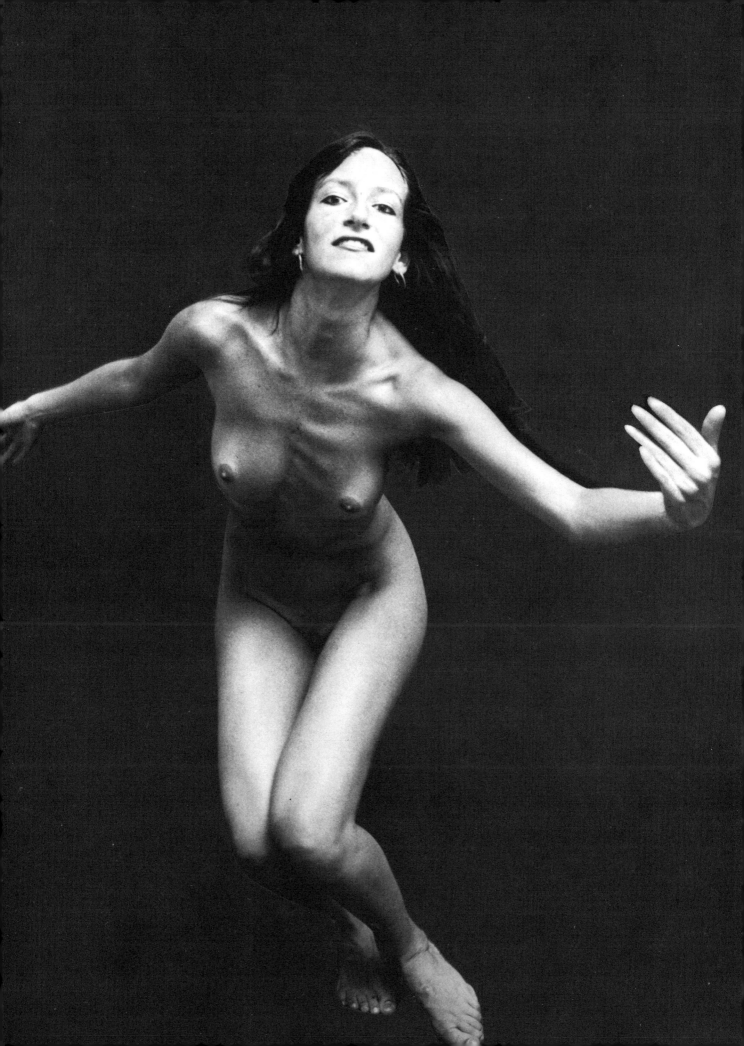

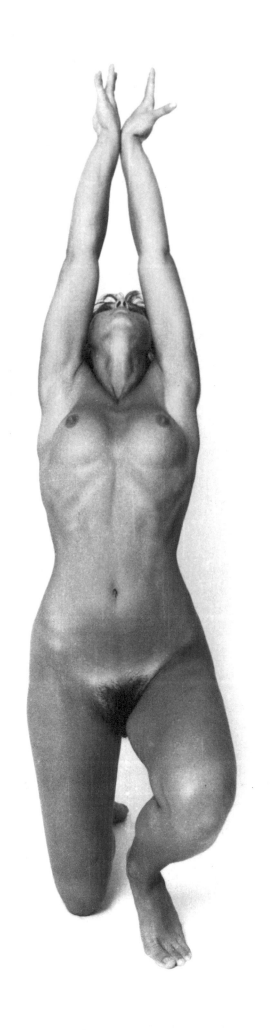

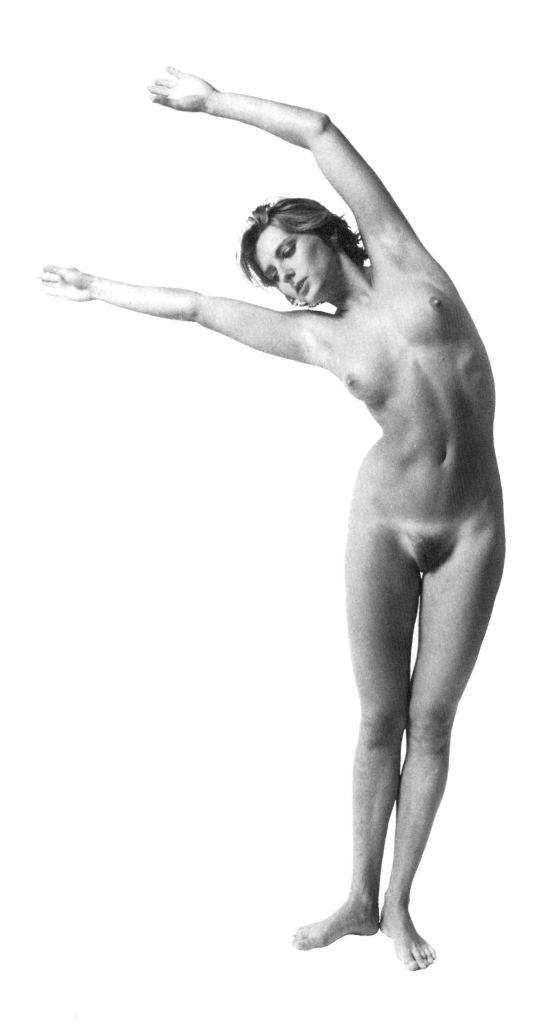

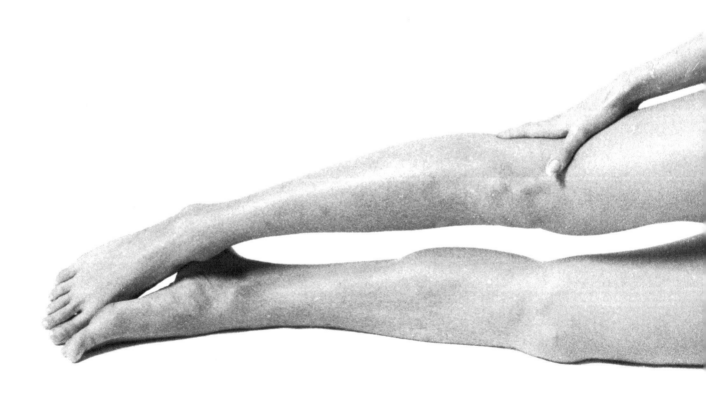

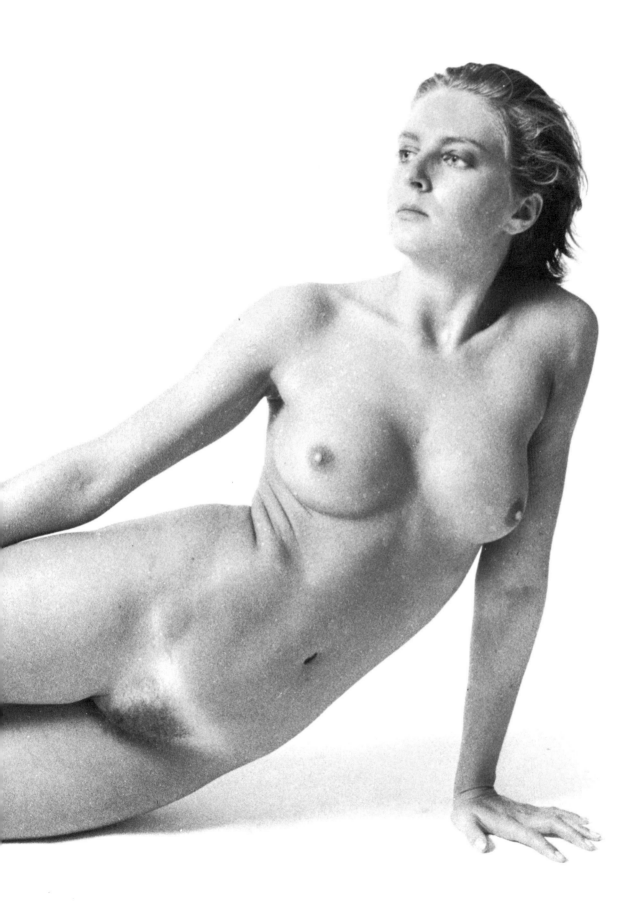

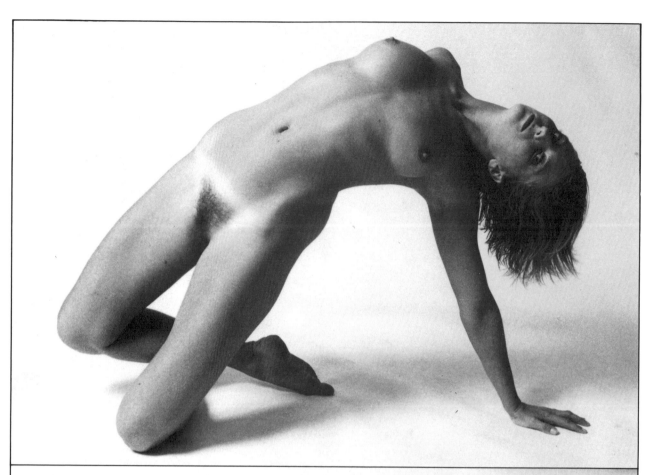

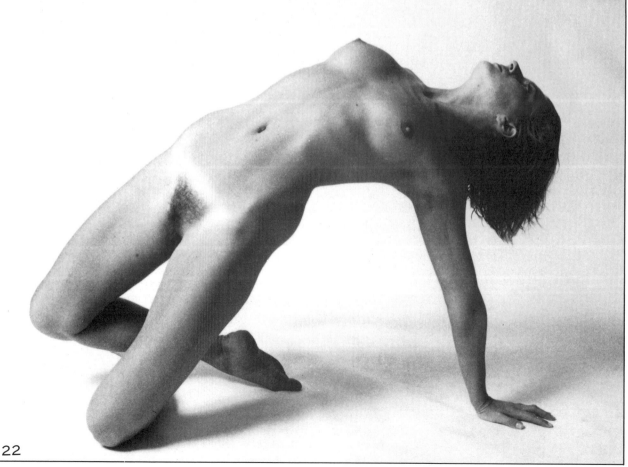

22

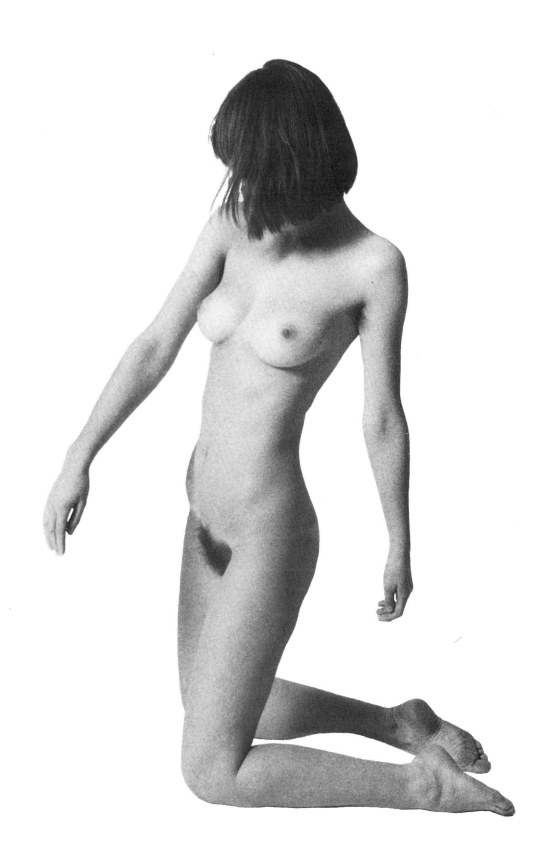

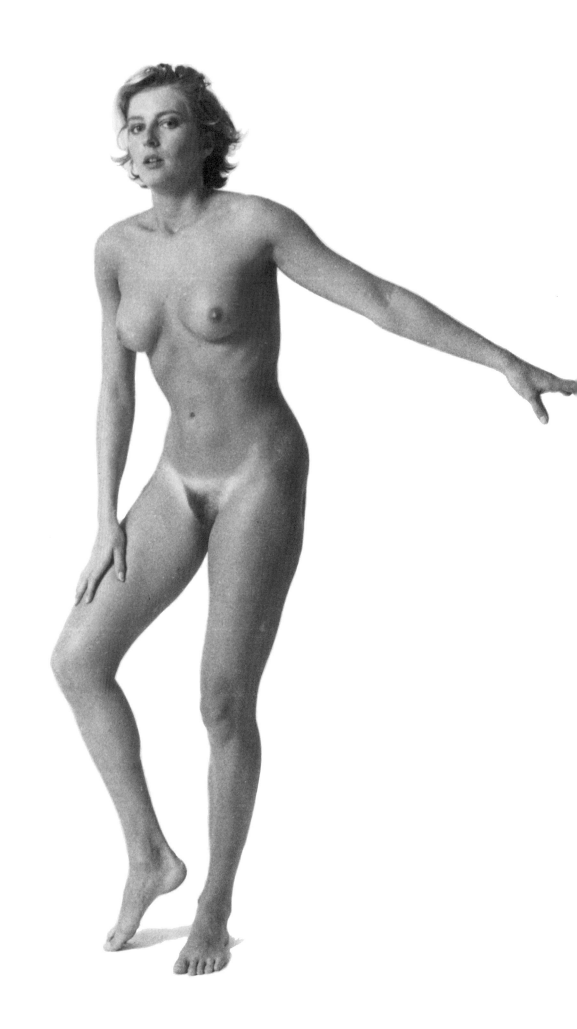

24

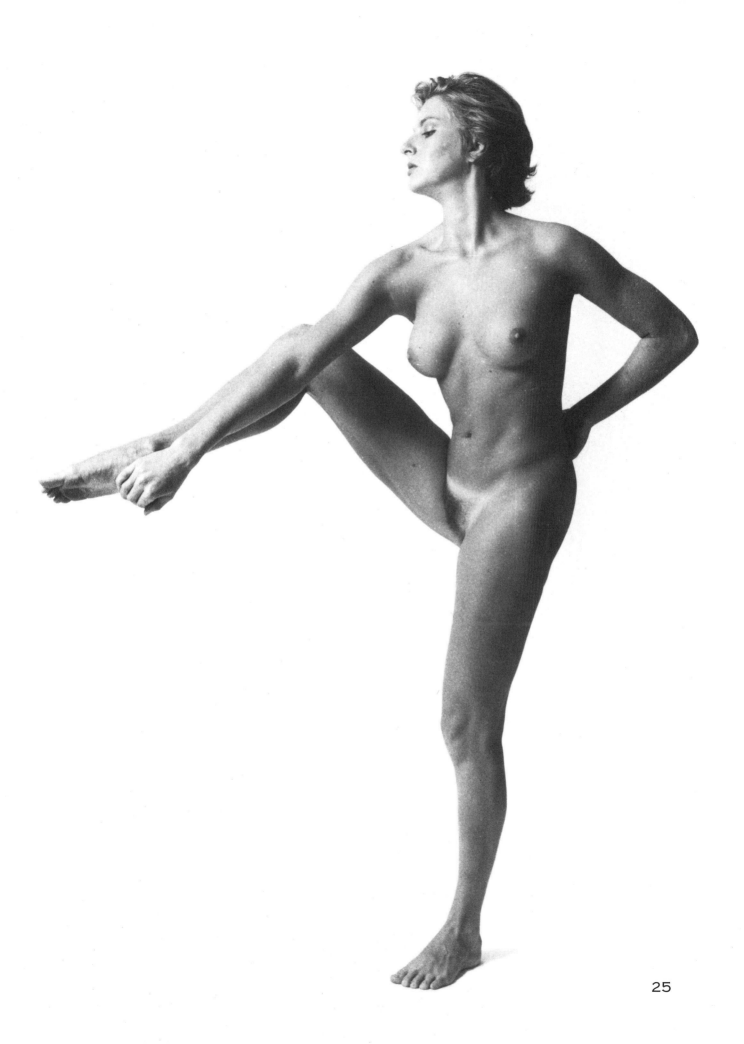

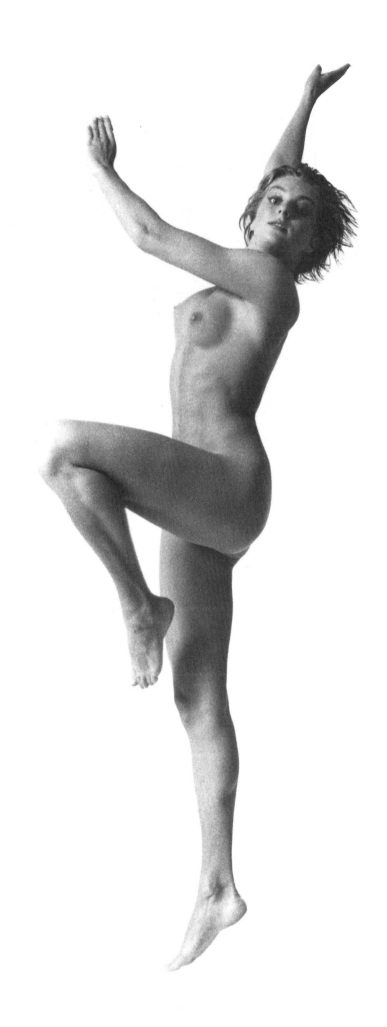

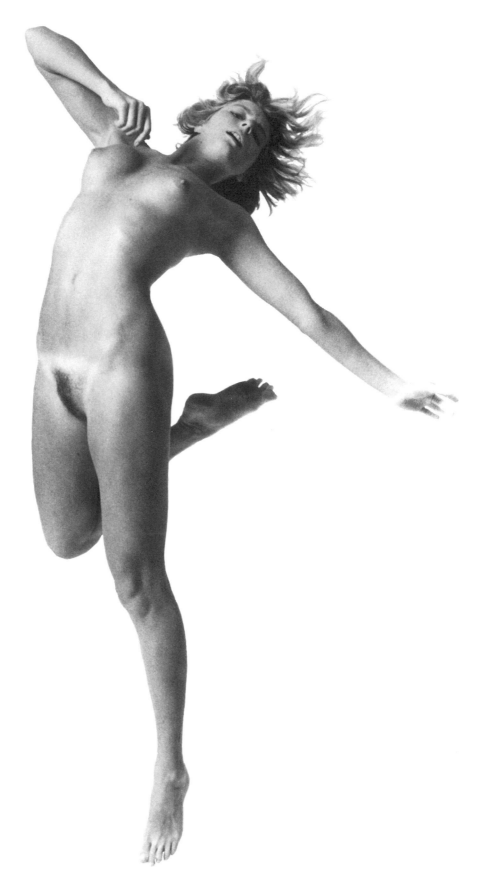

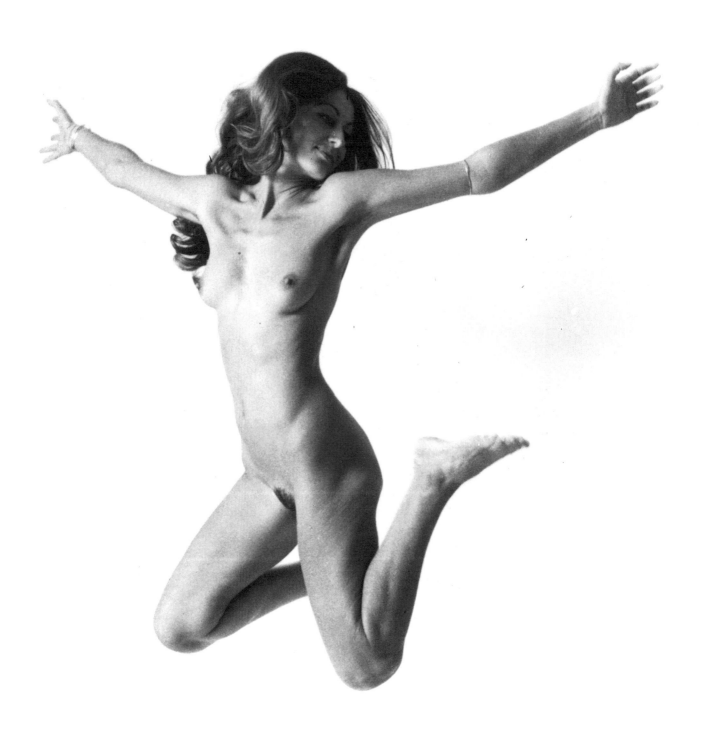

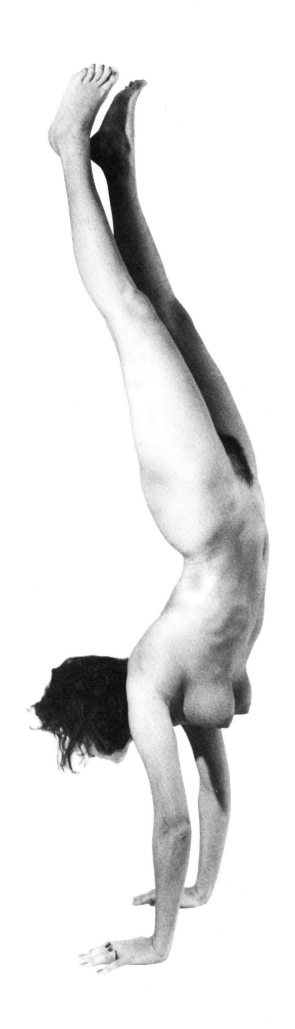

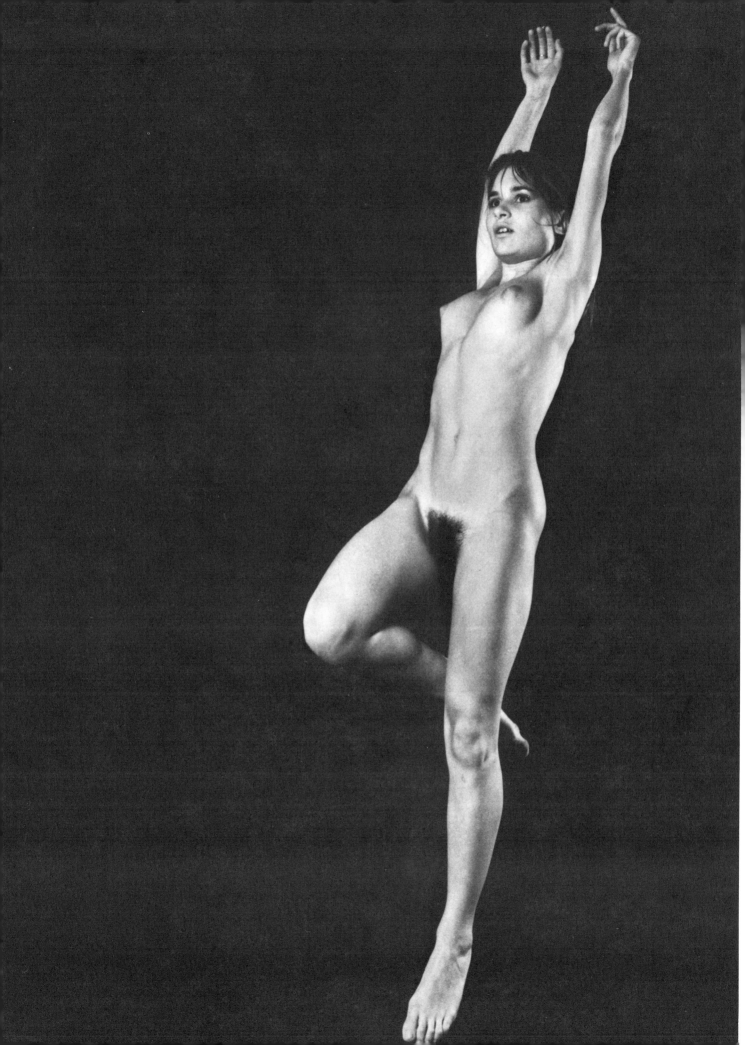

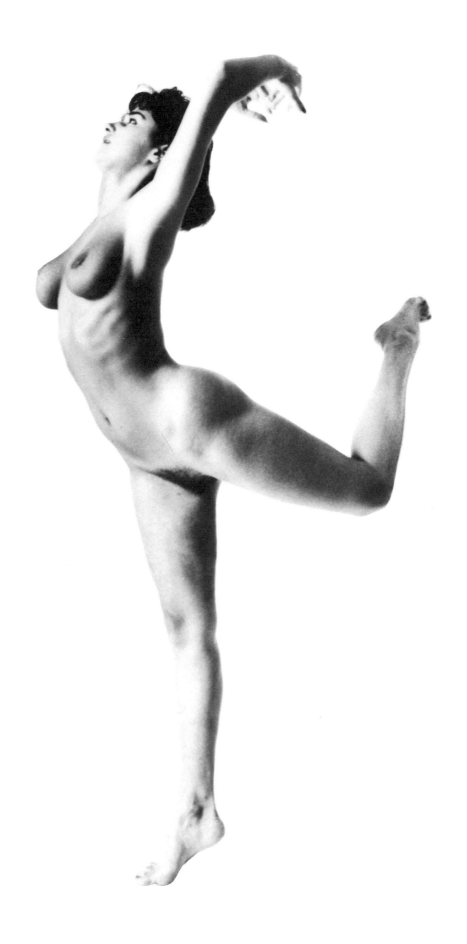

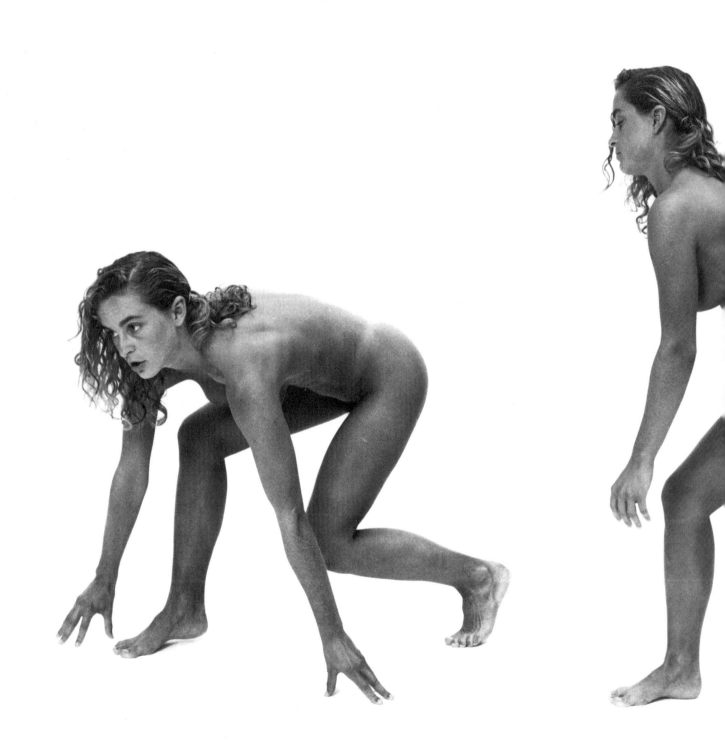

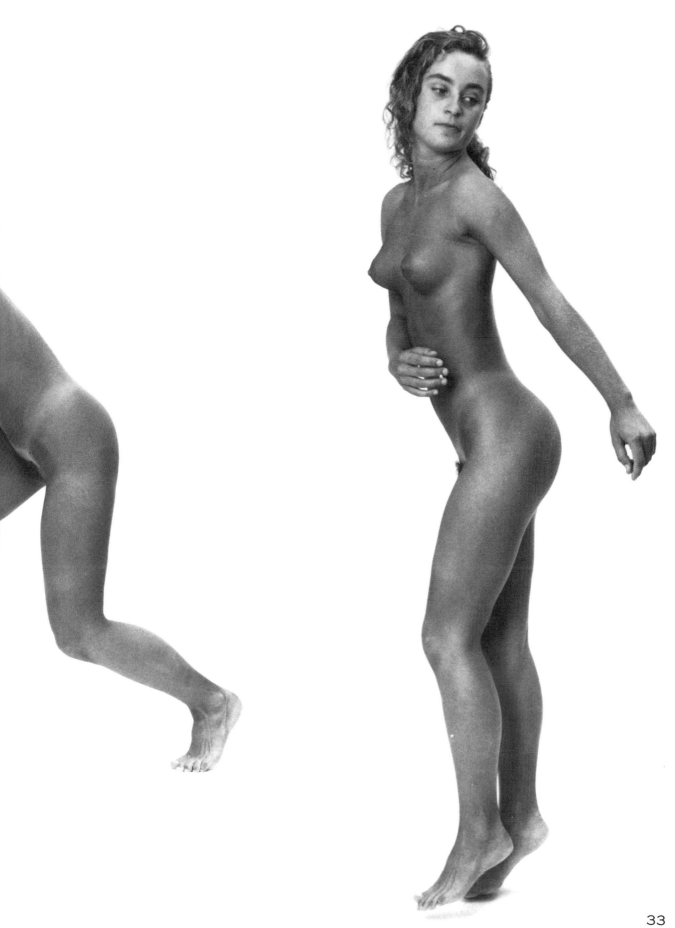

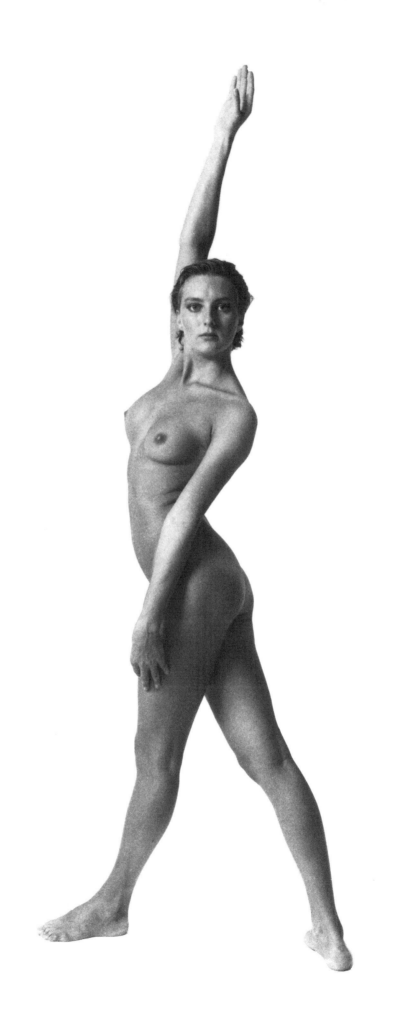

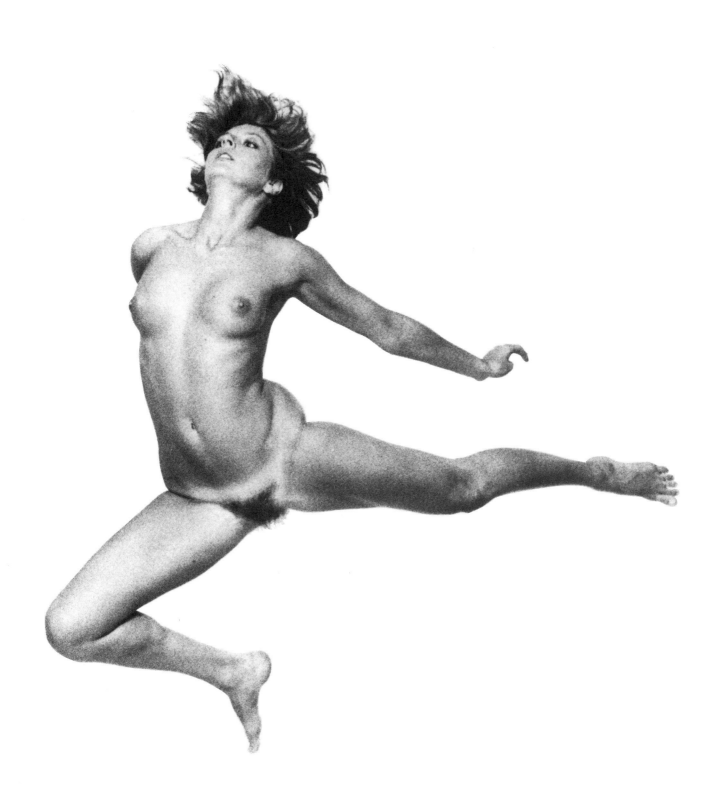

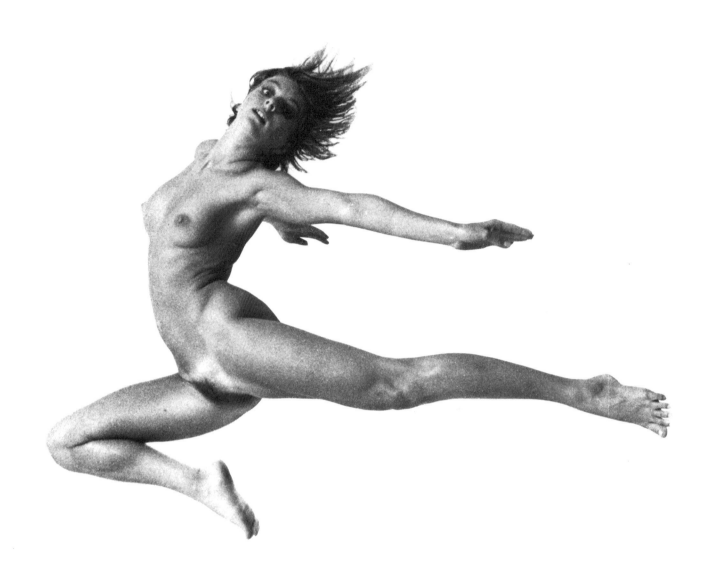

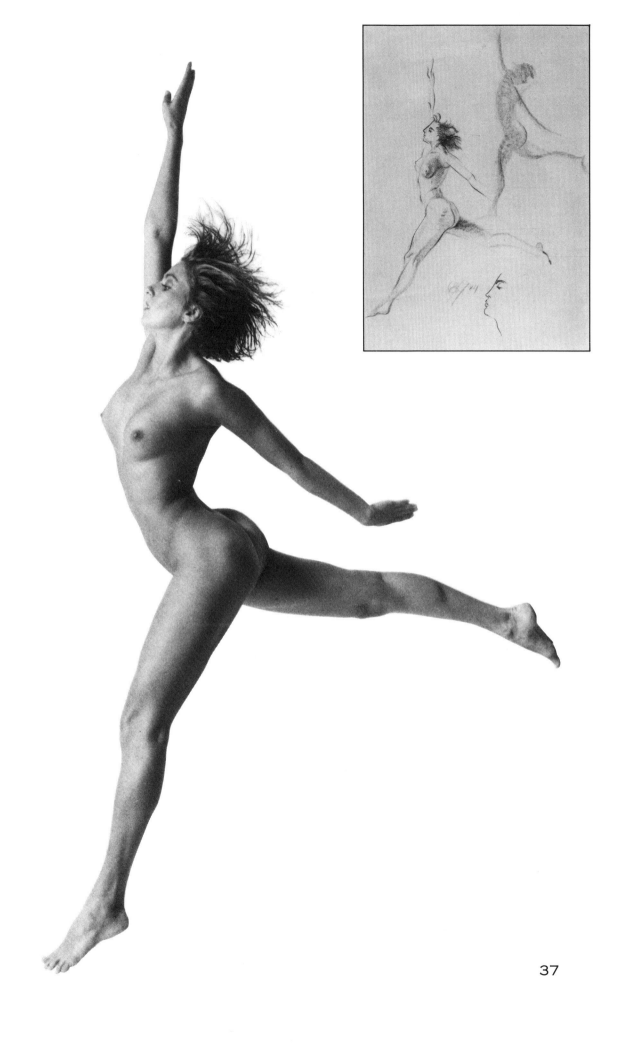

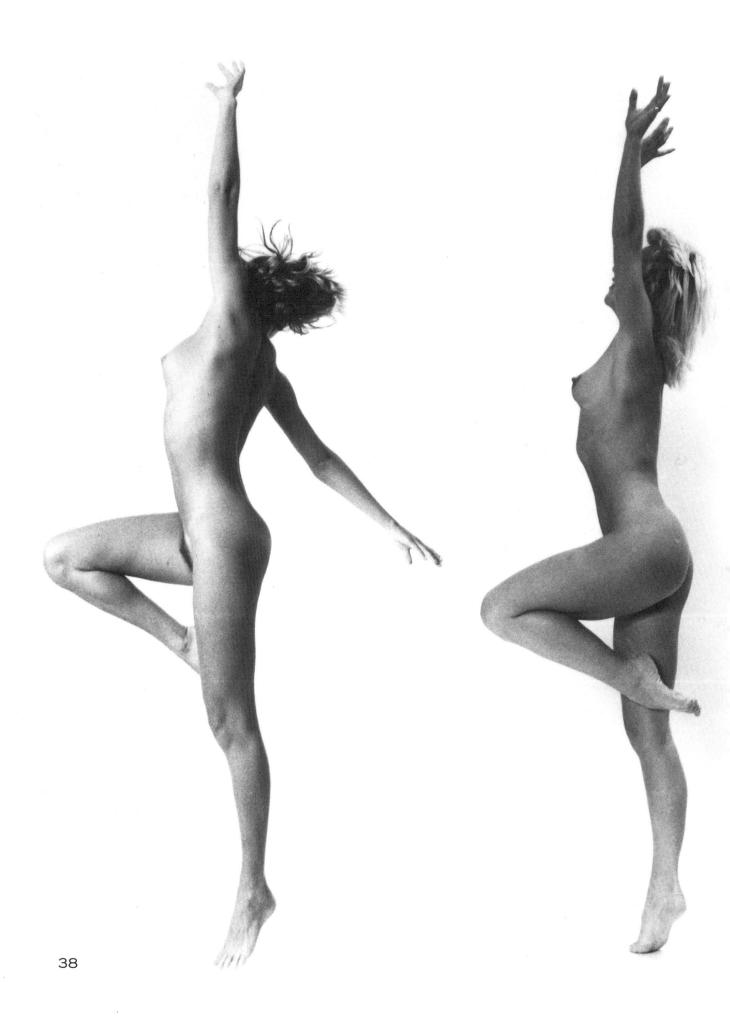

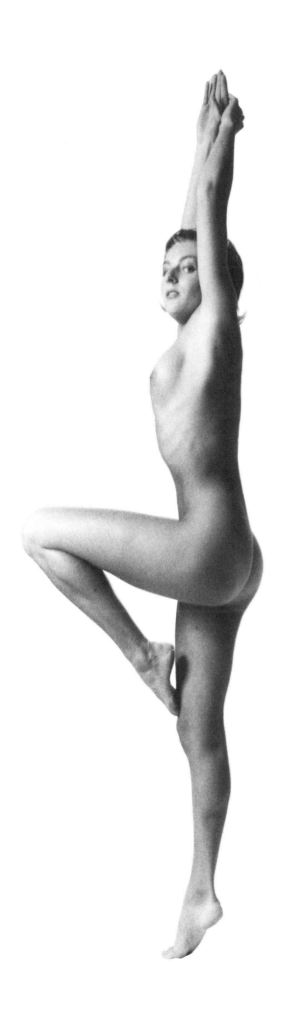

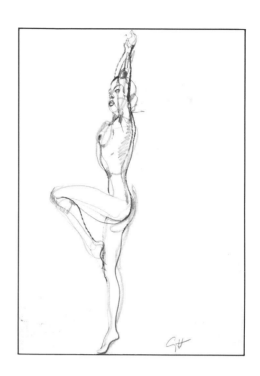

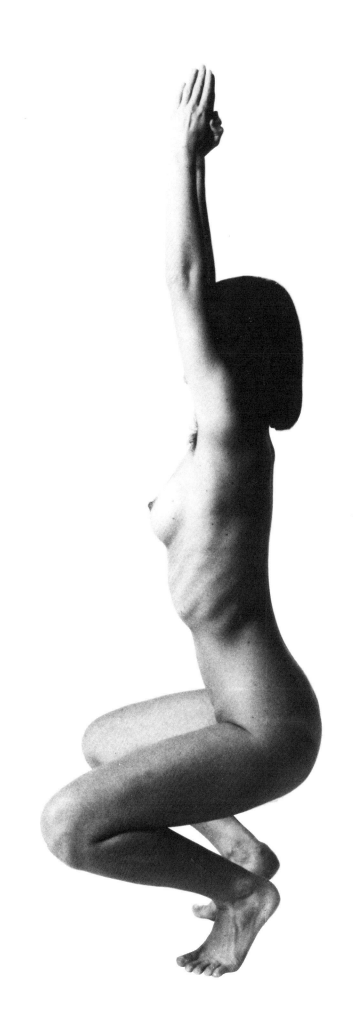

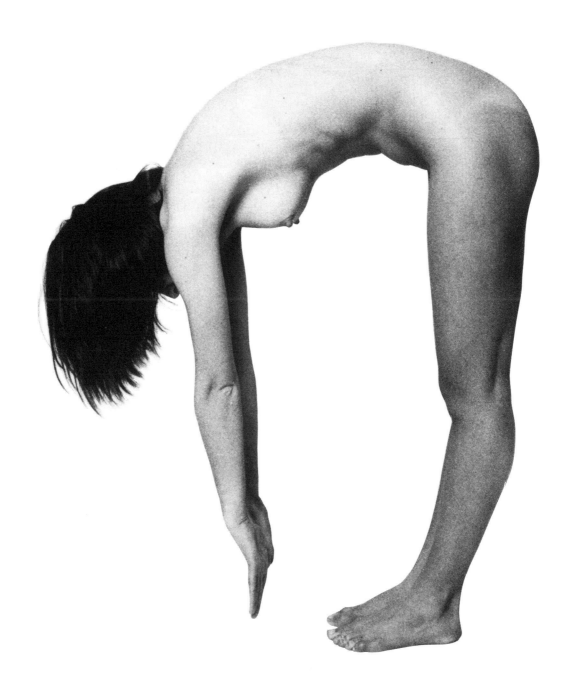

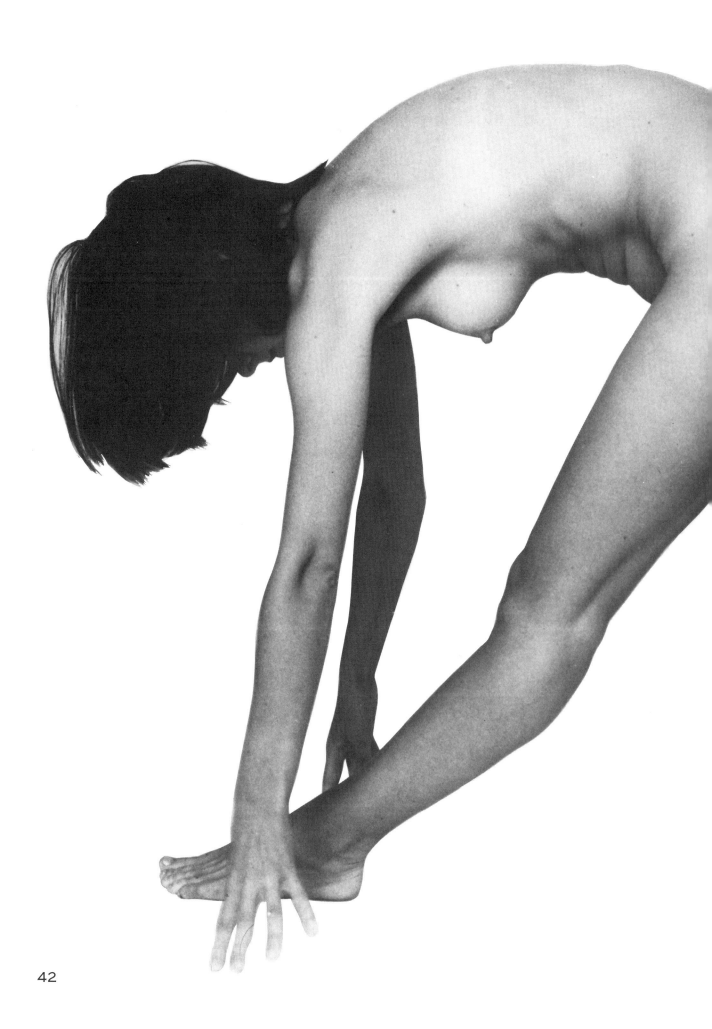

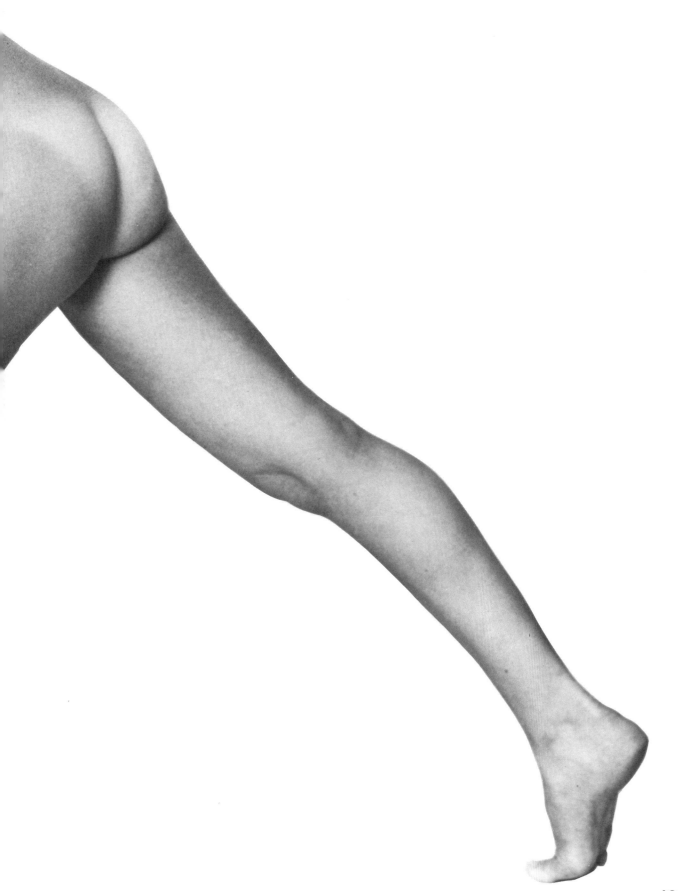

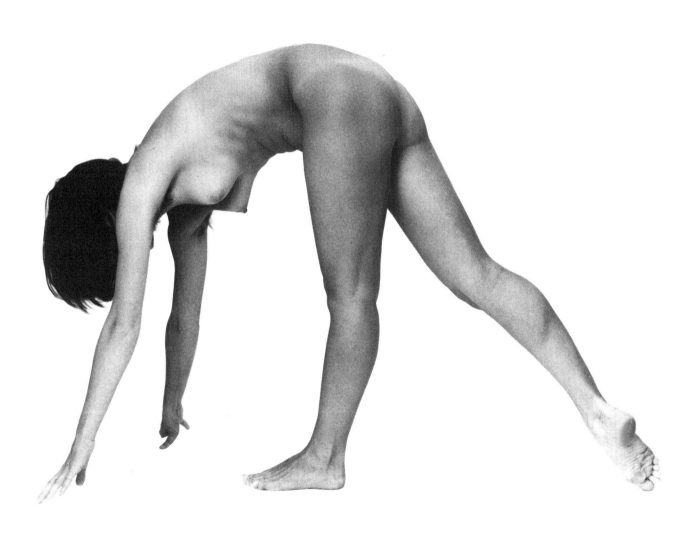

44

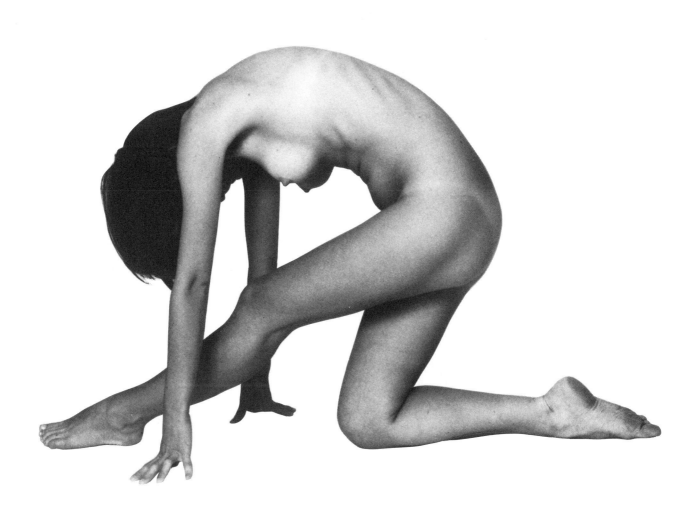

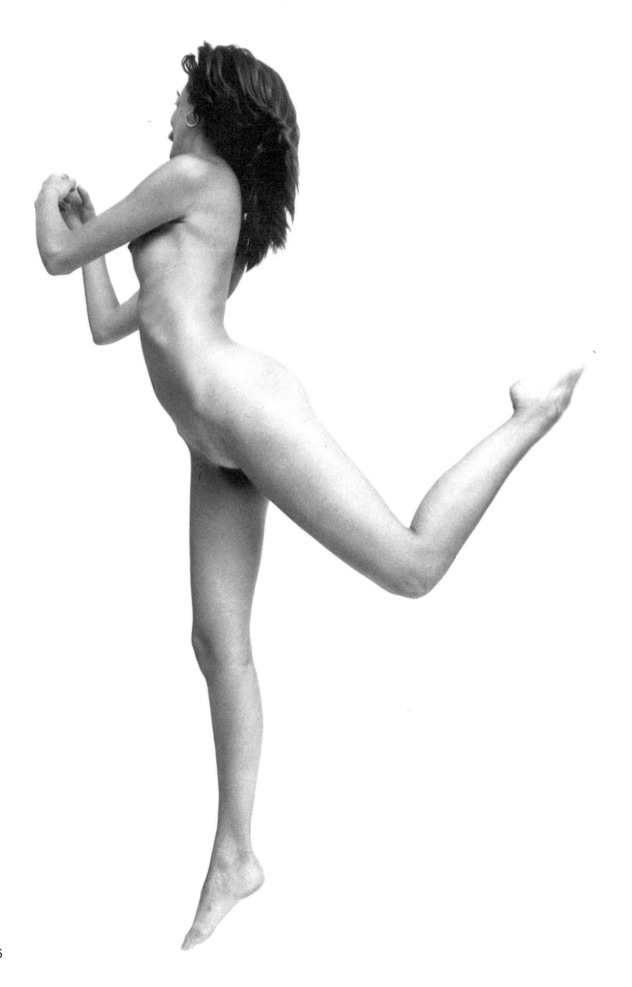

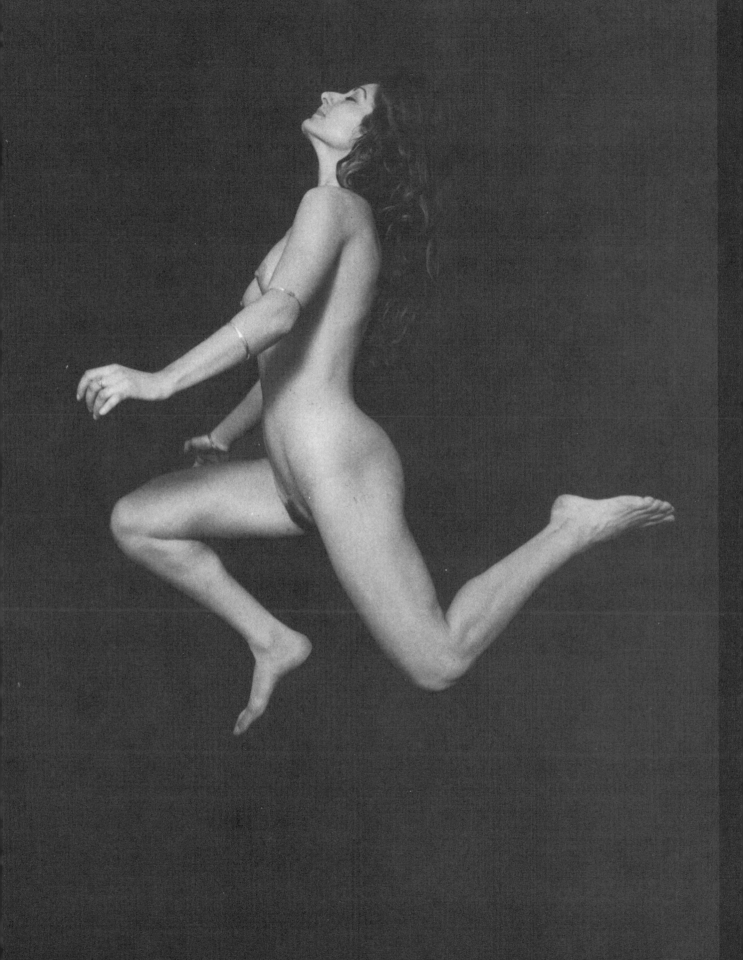

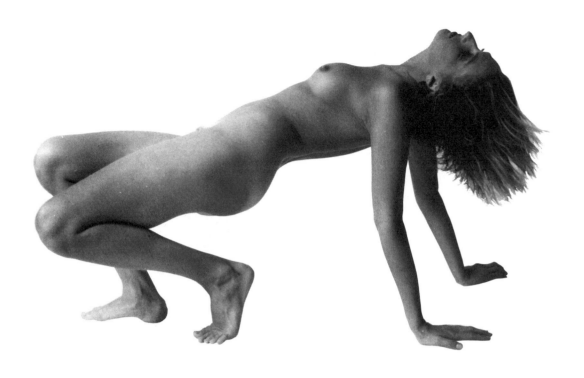

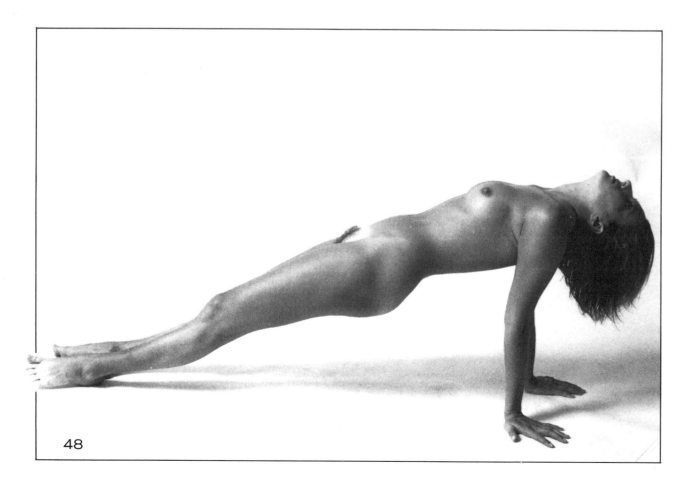

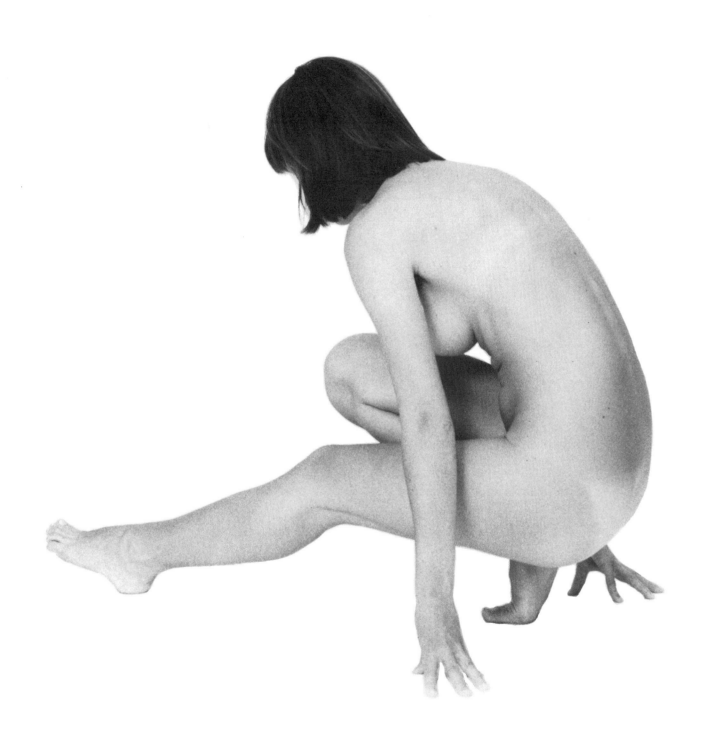

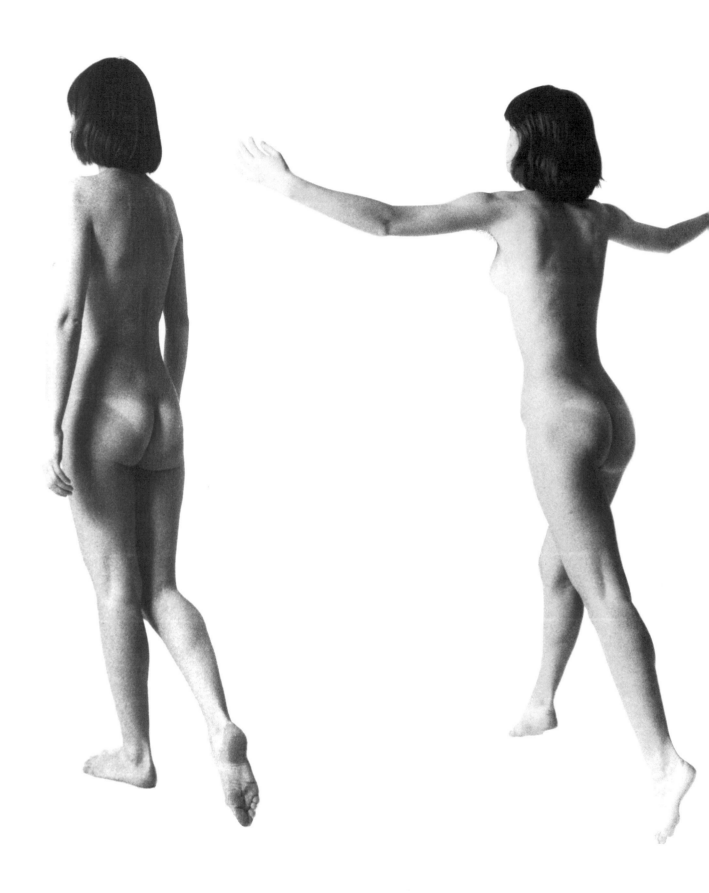

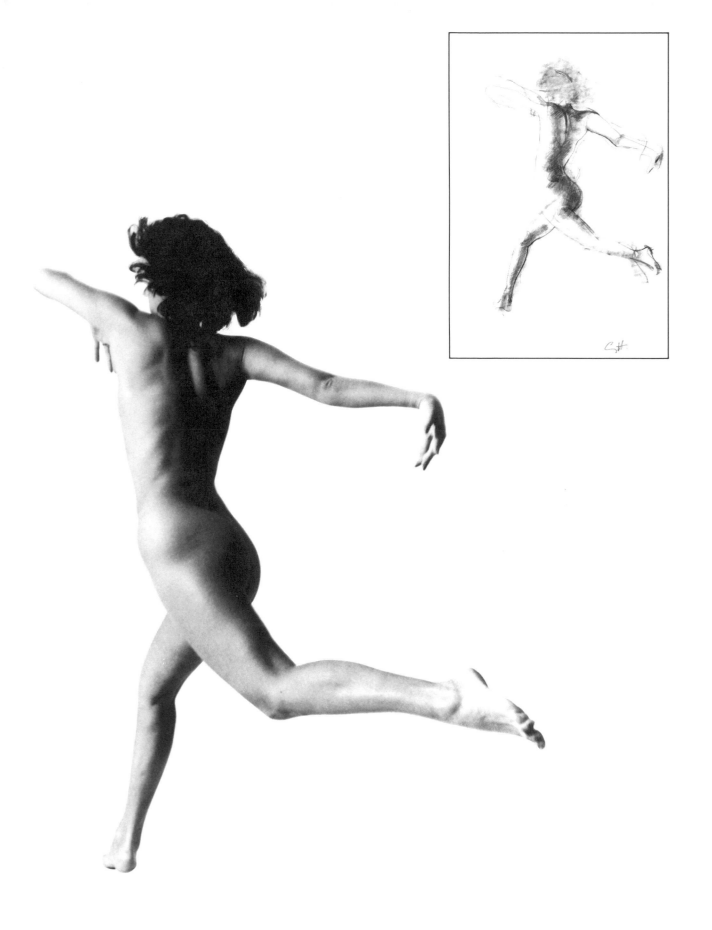

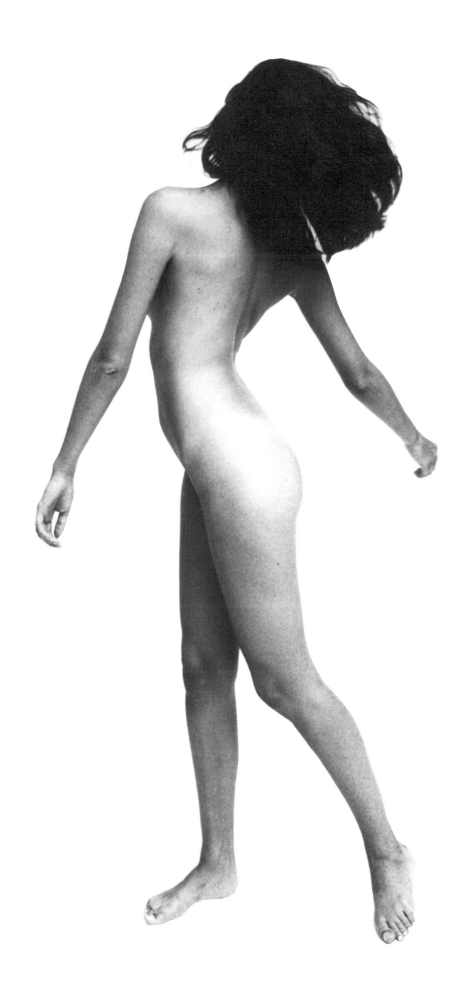

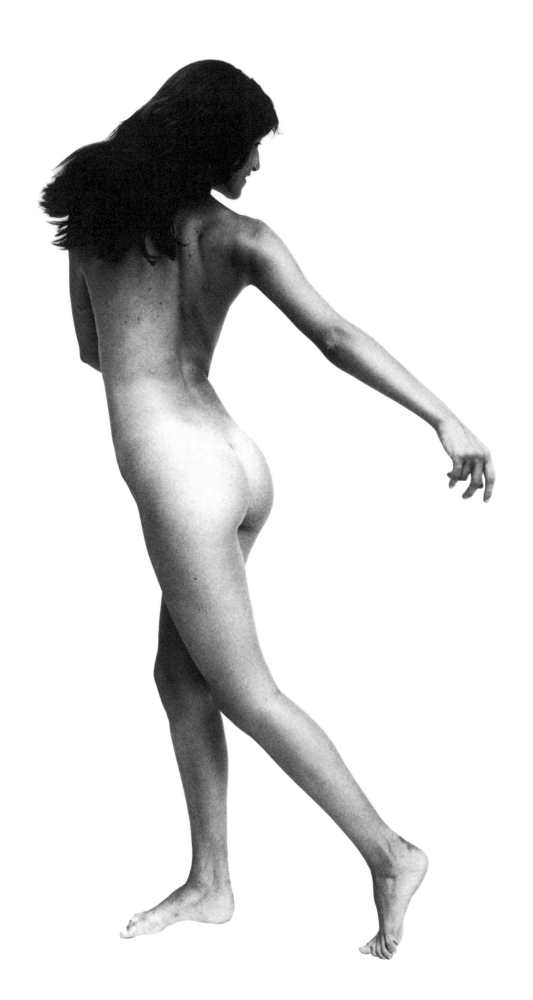

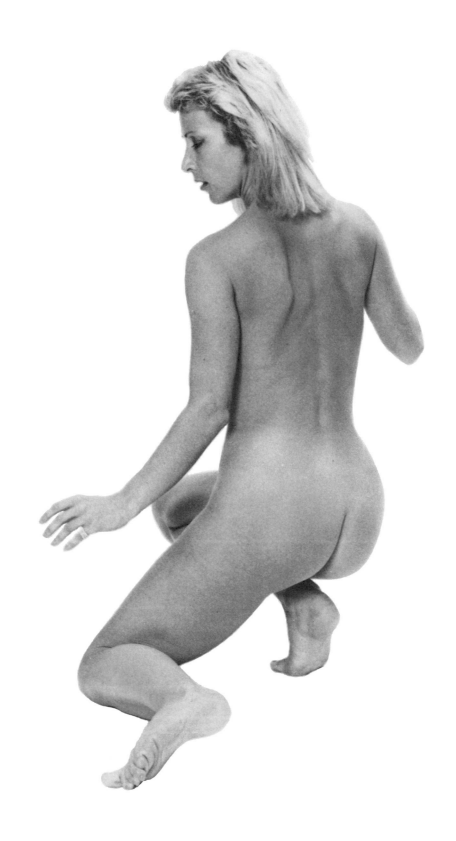

54

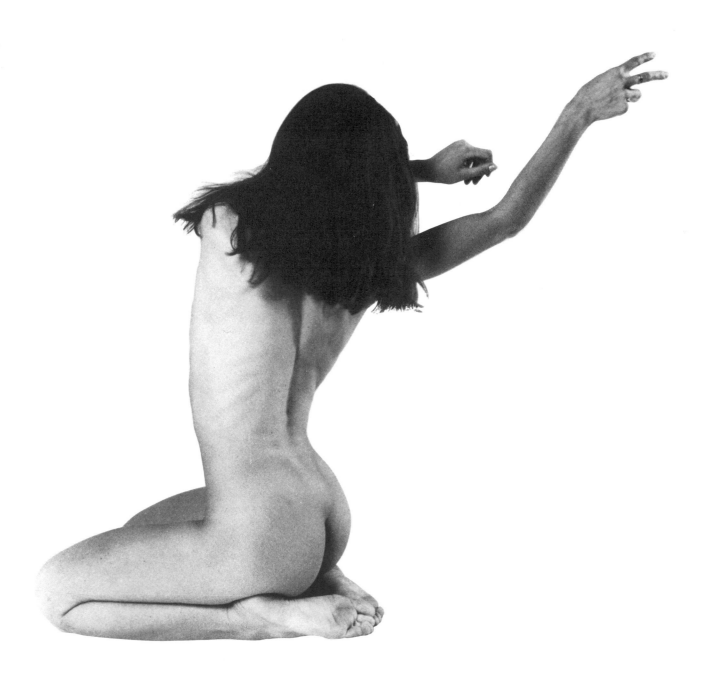

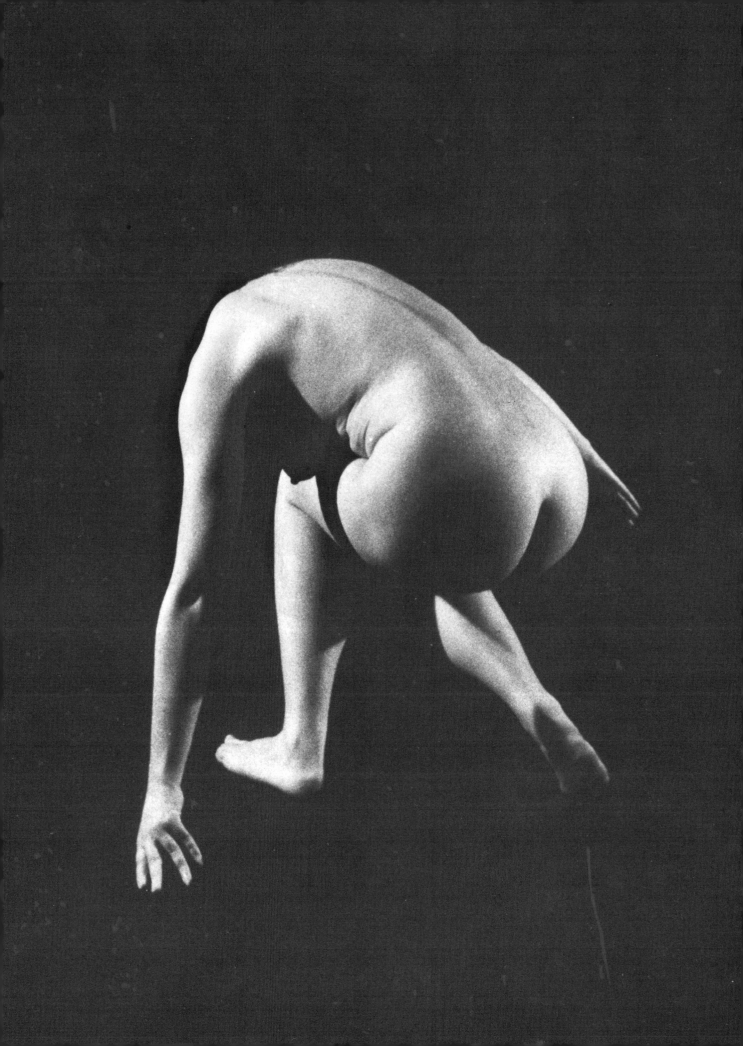

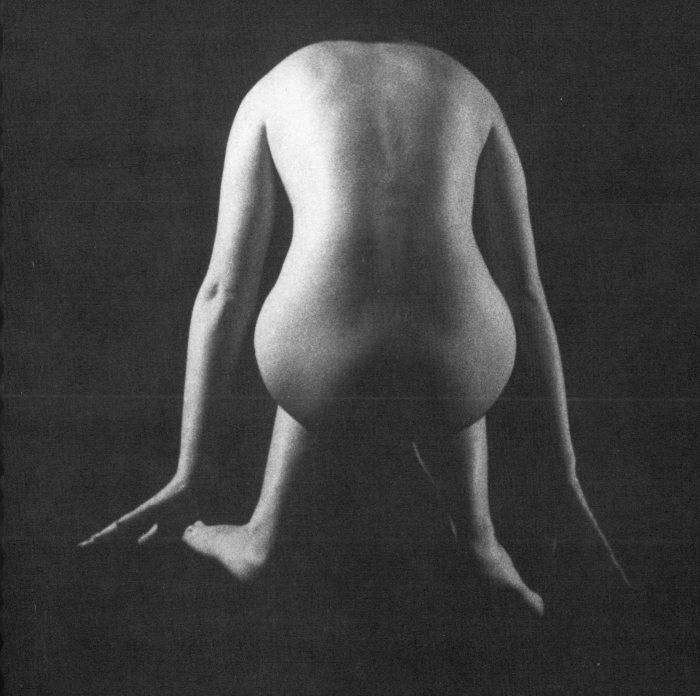

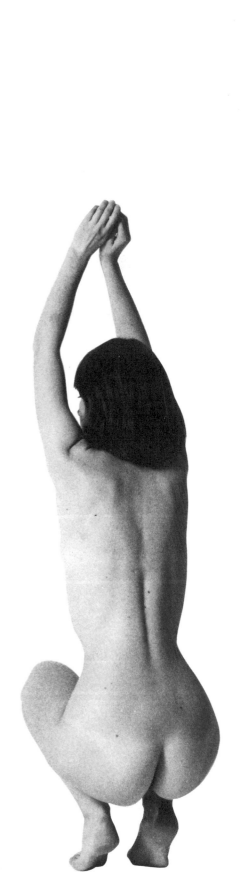
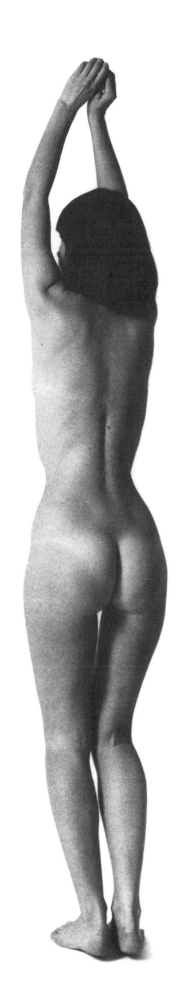

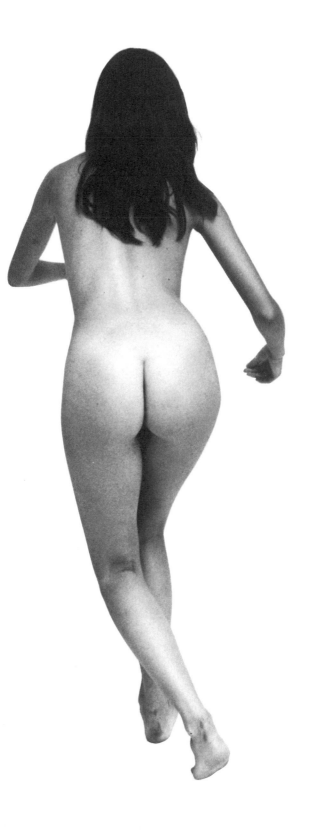
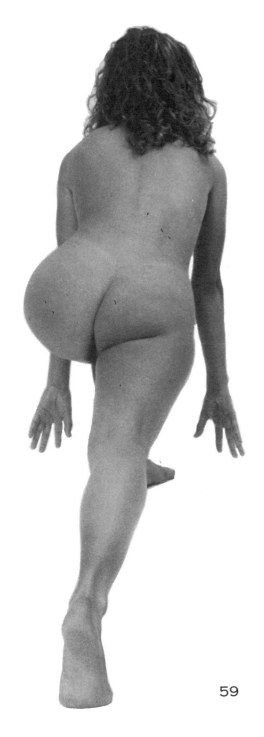

59

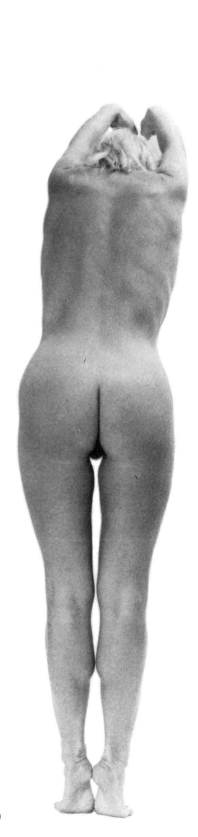
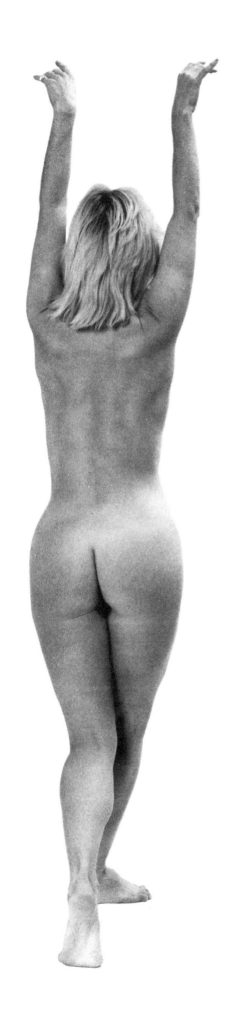

60

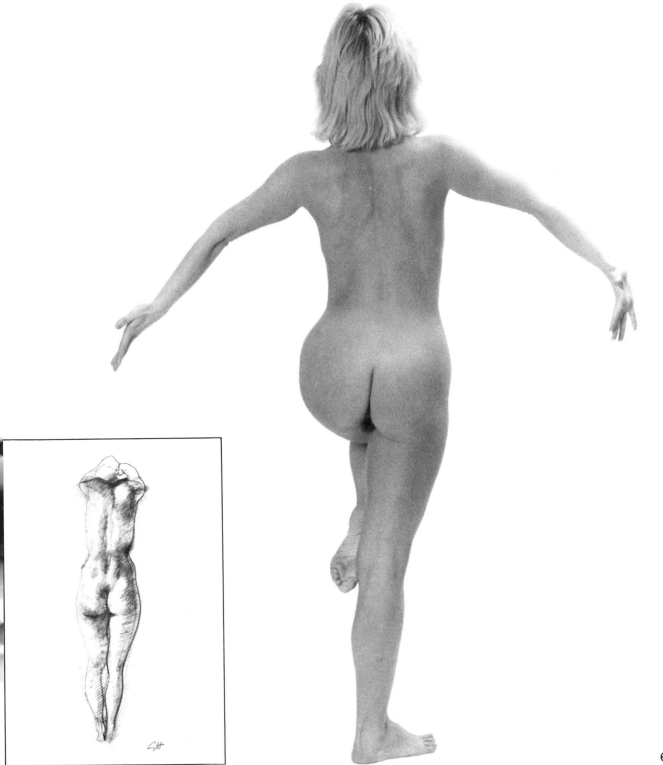

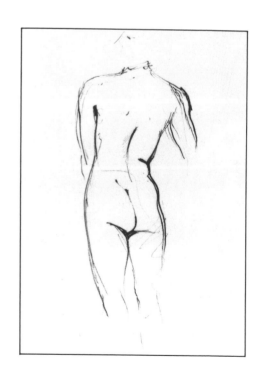

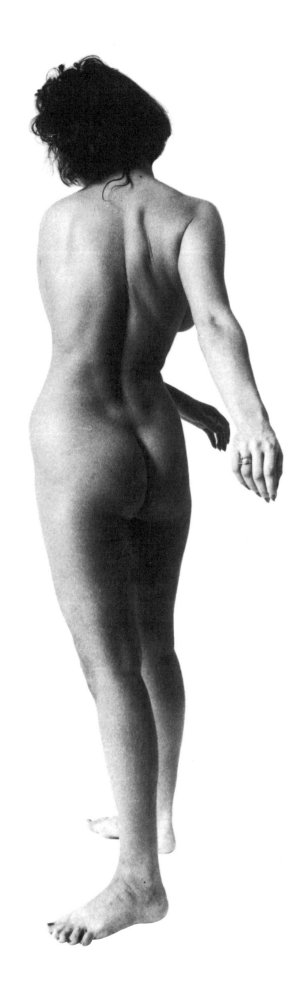

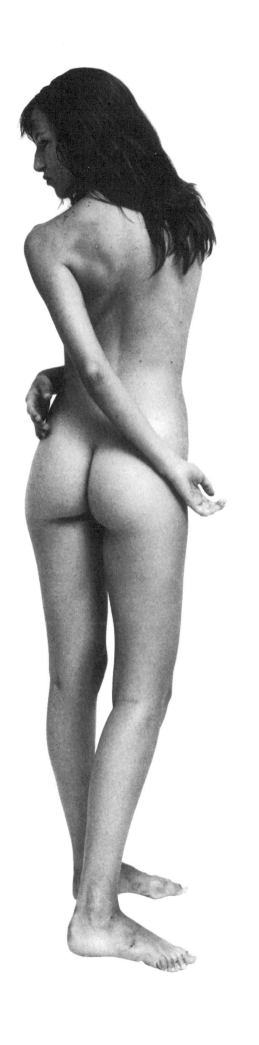
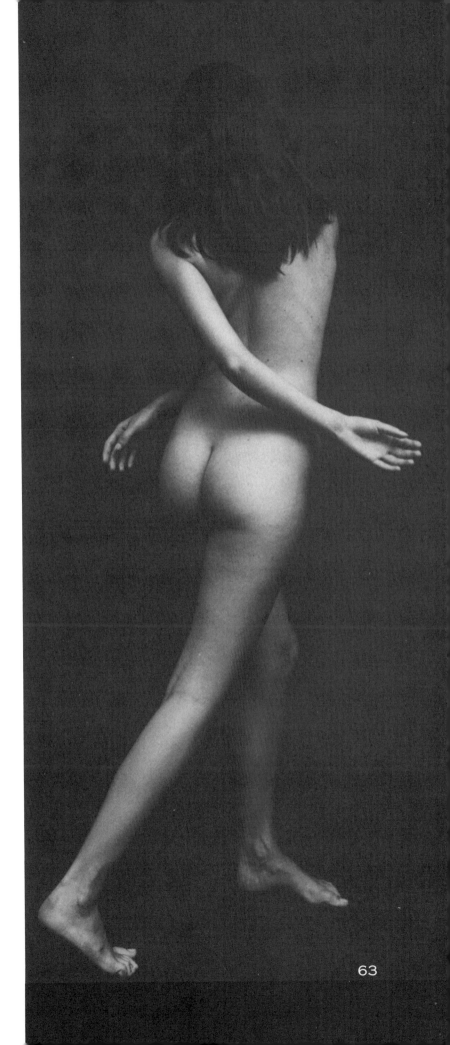

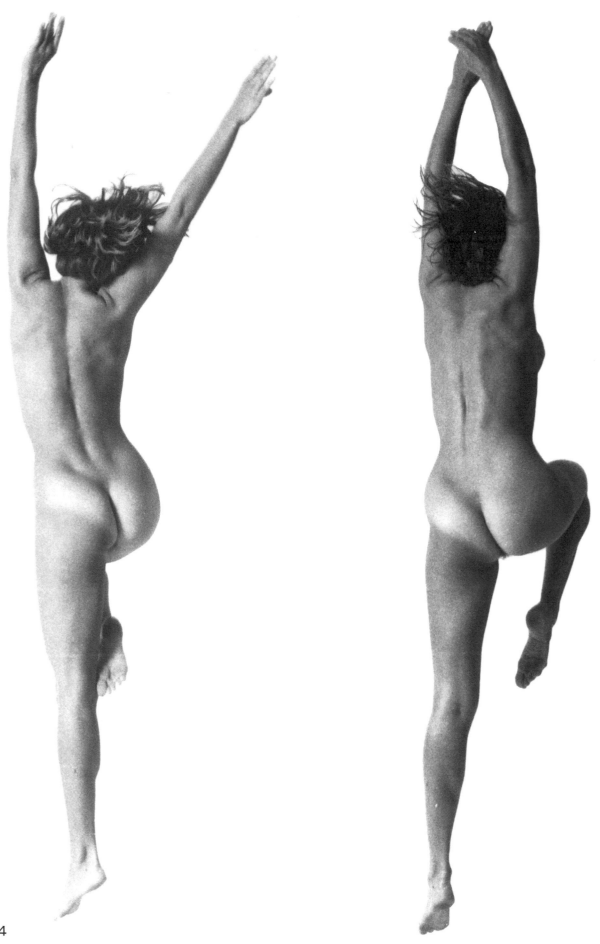

64

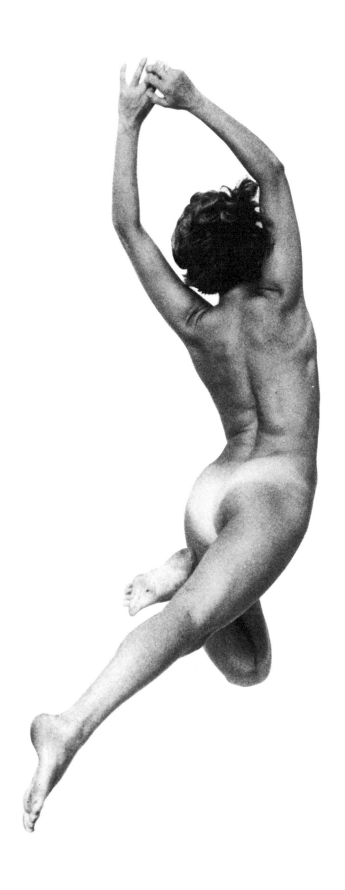

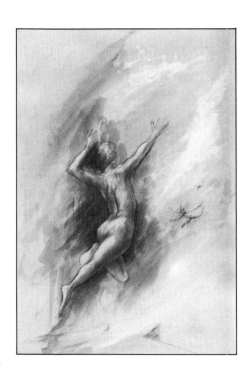

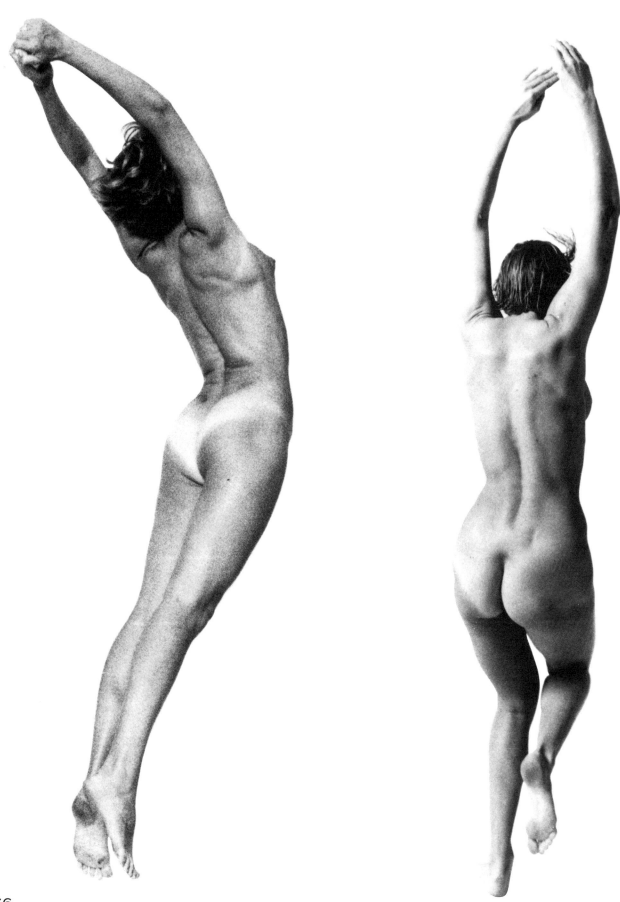

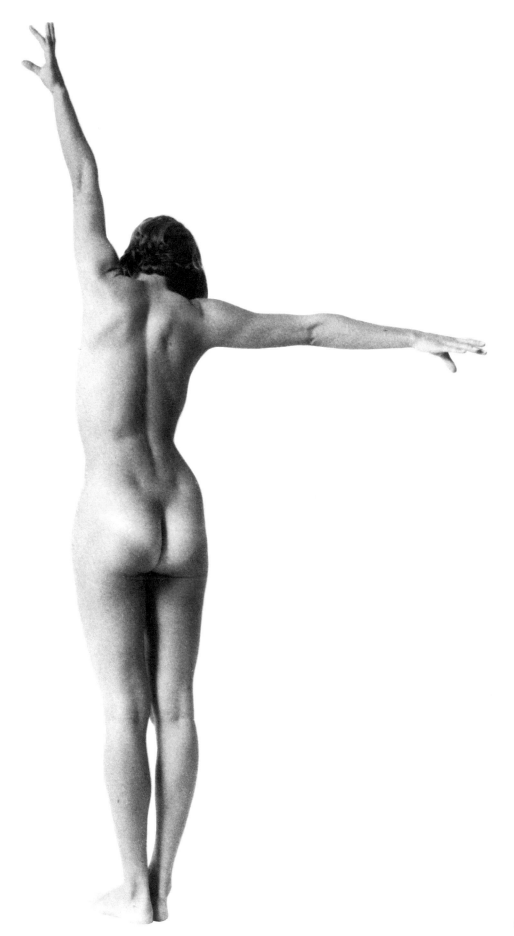

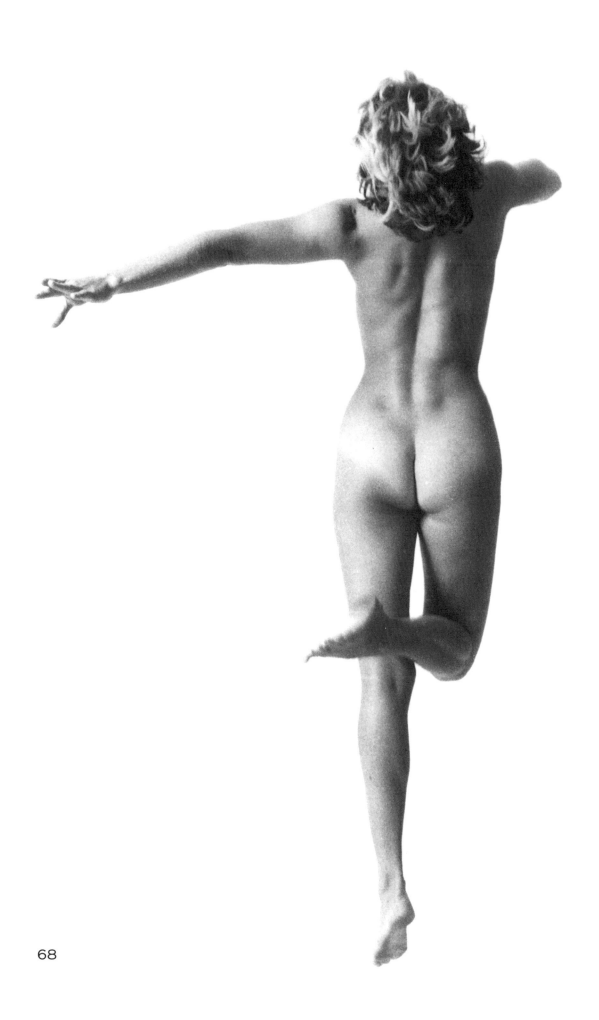

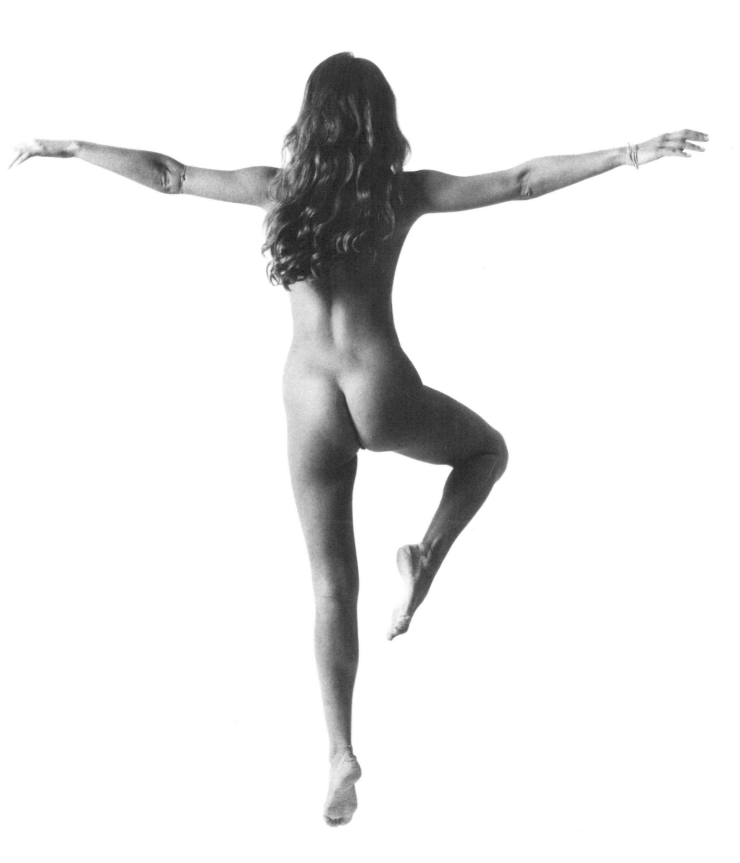

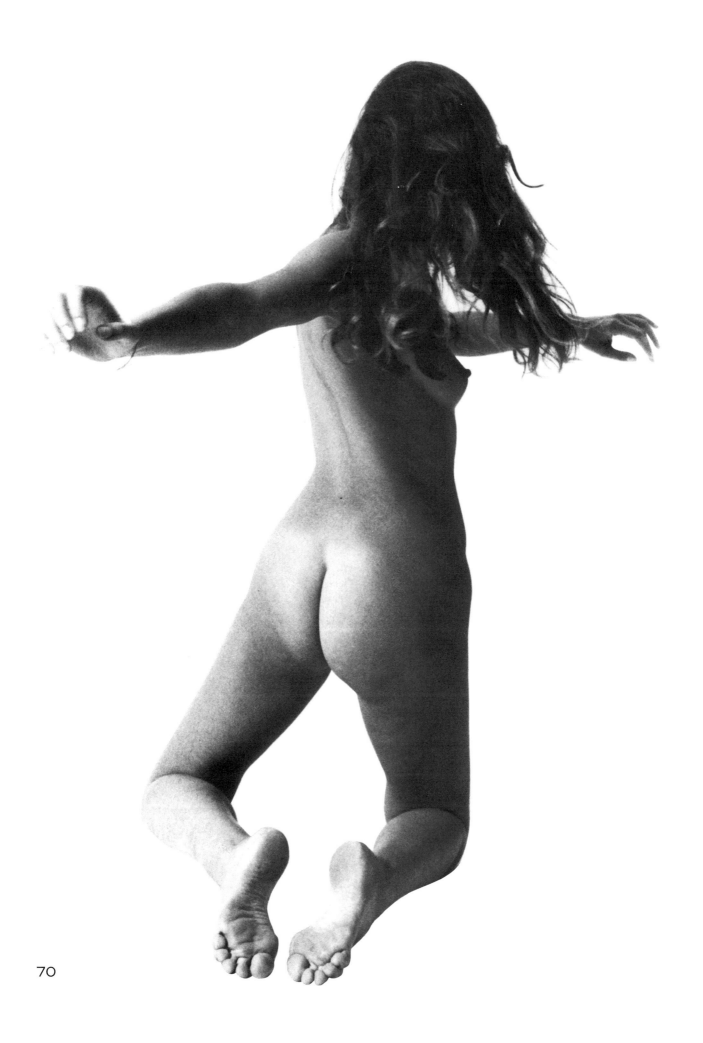

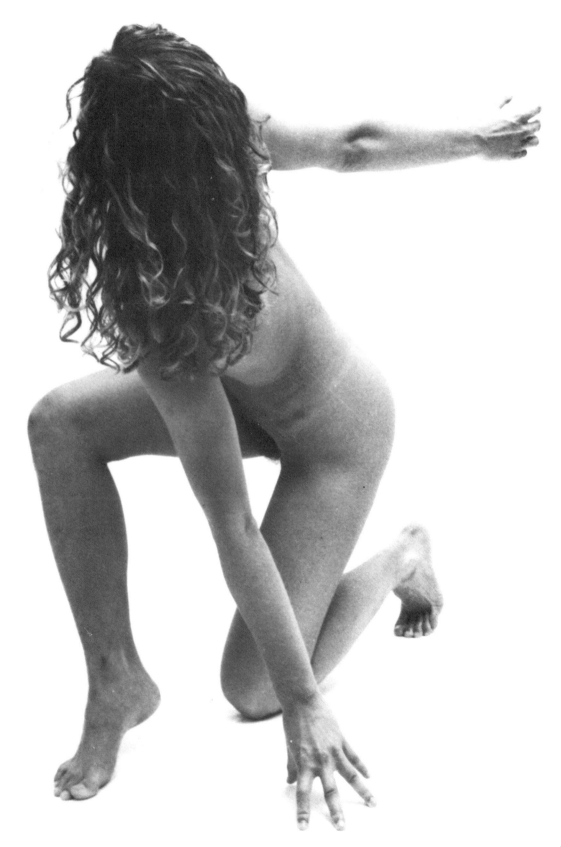

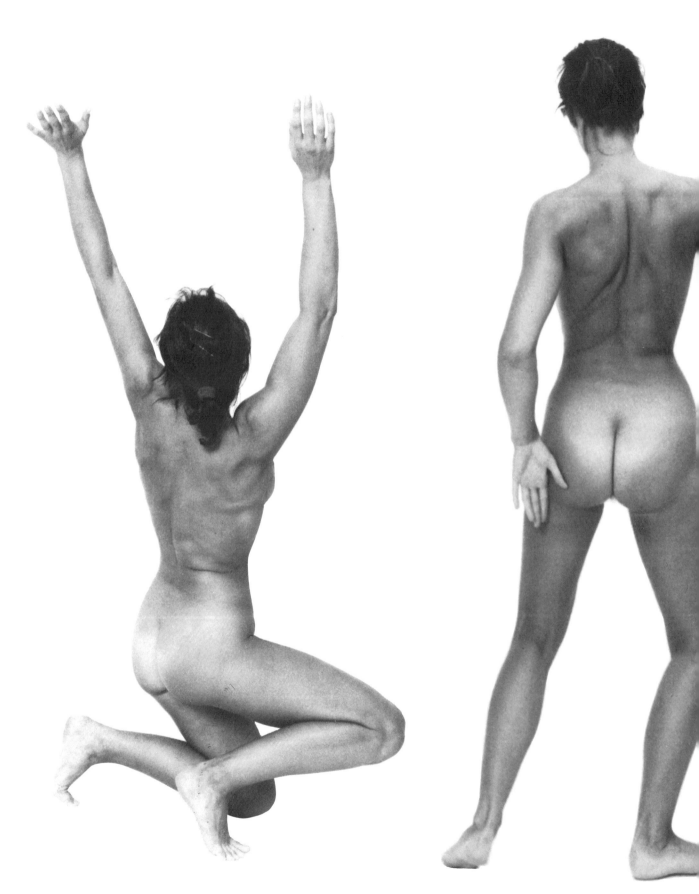

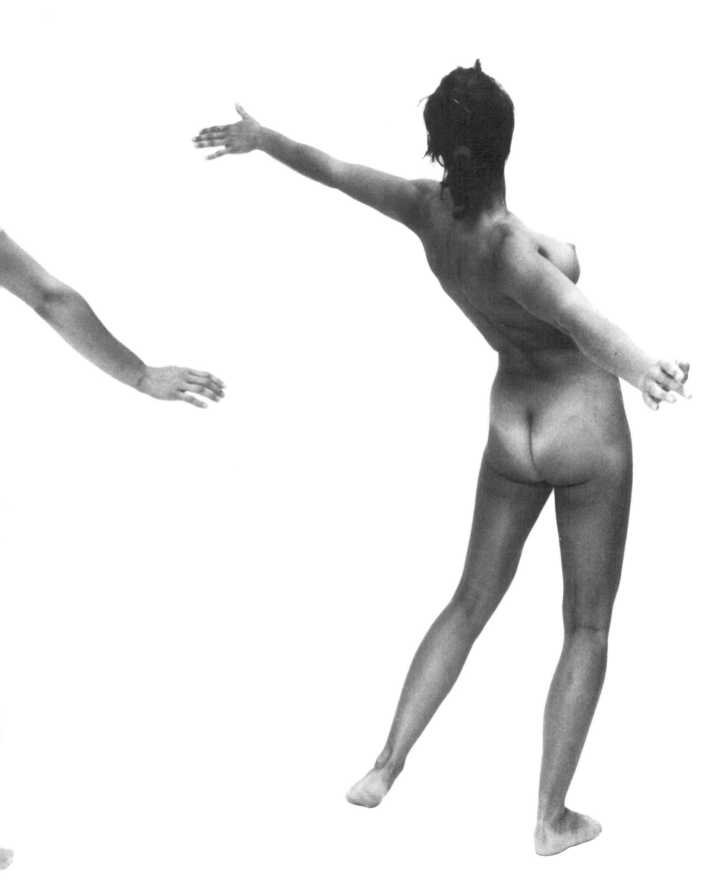

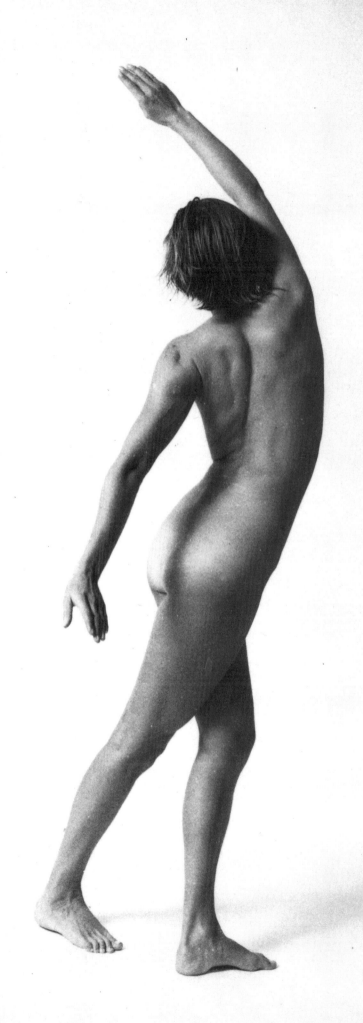

74

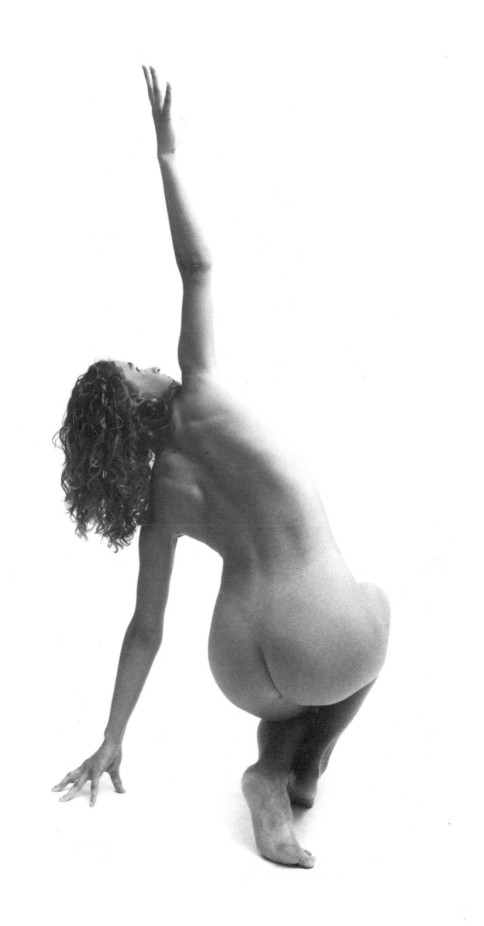

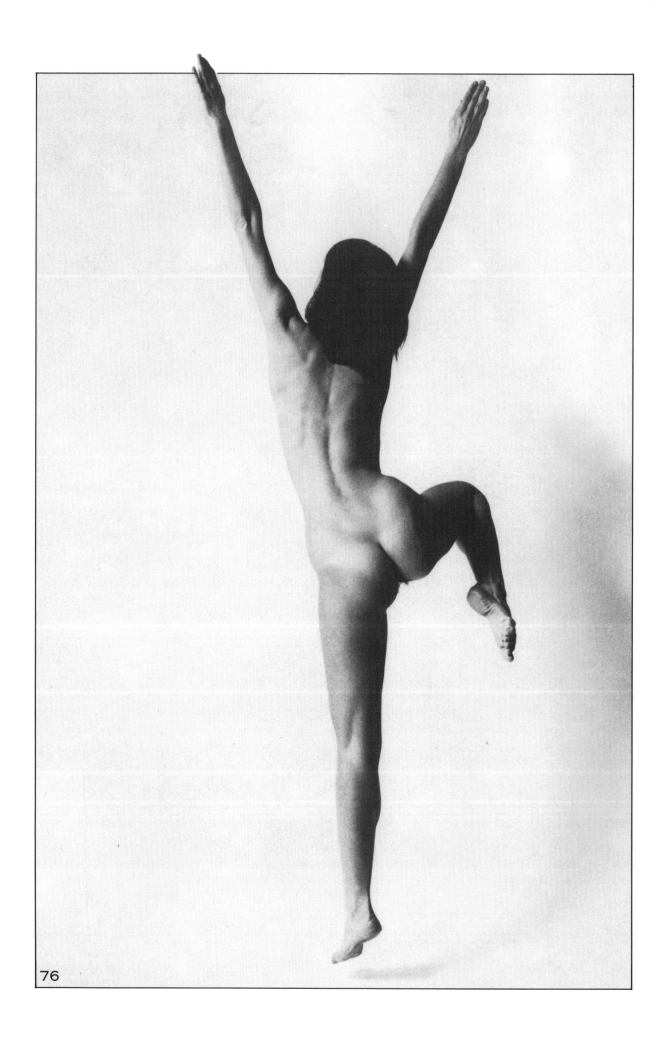

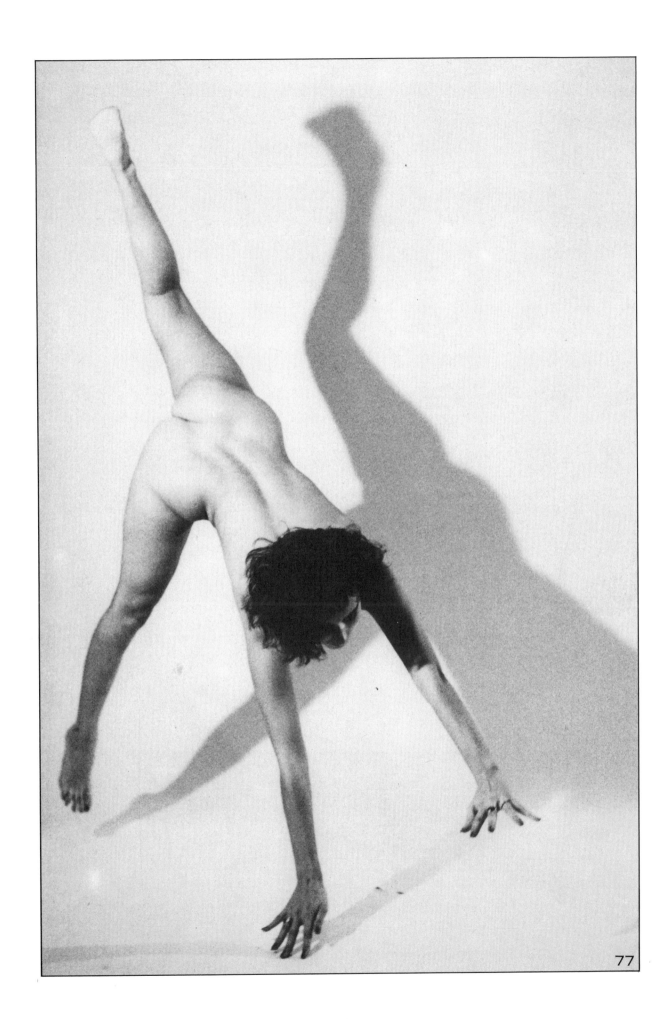

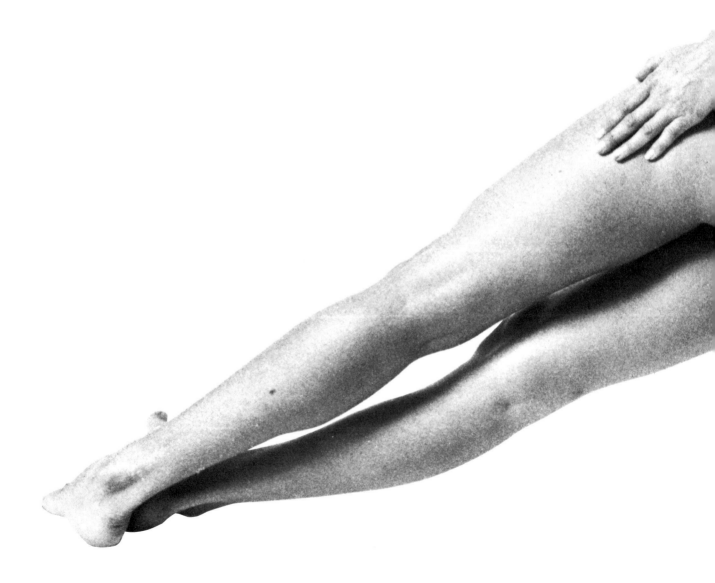

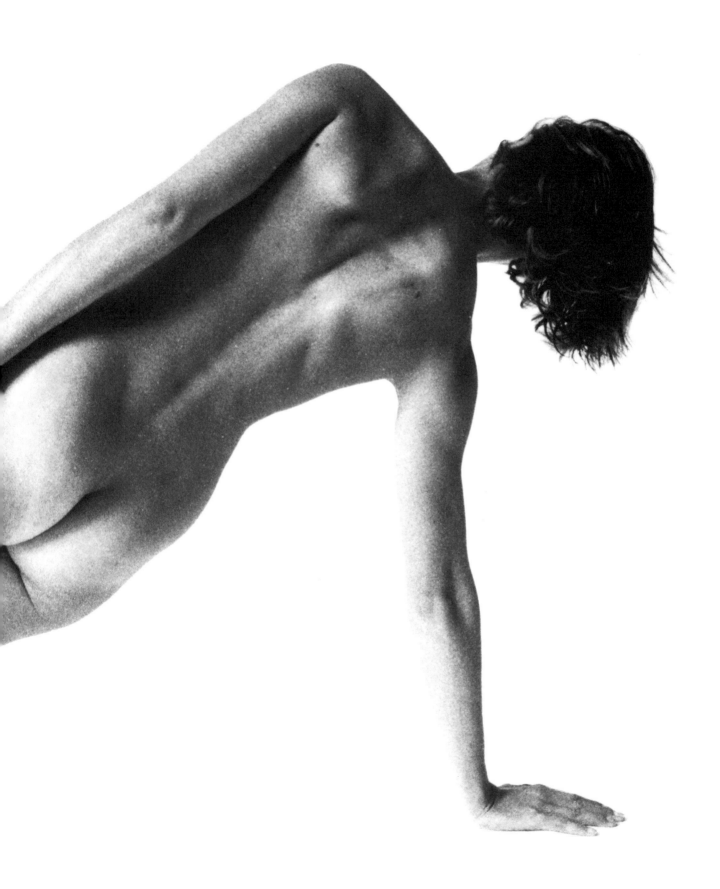

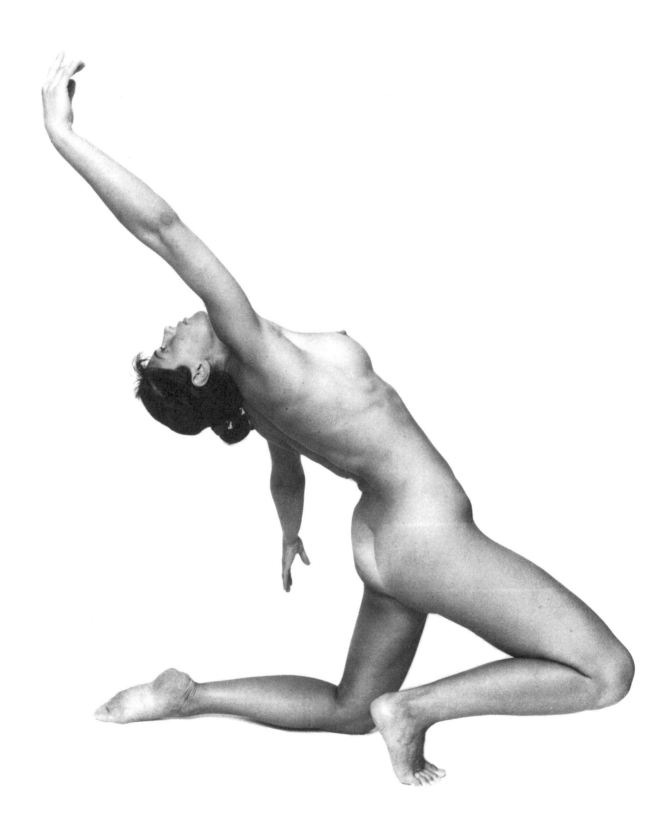

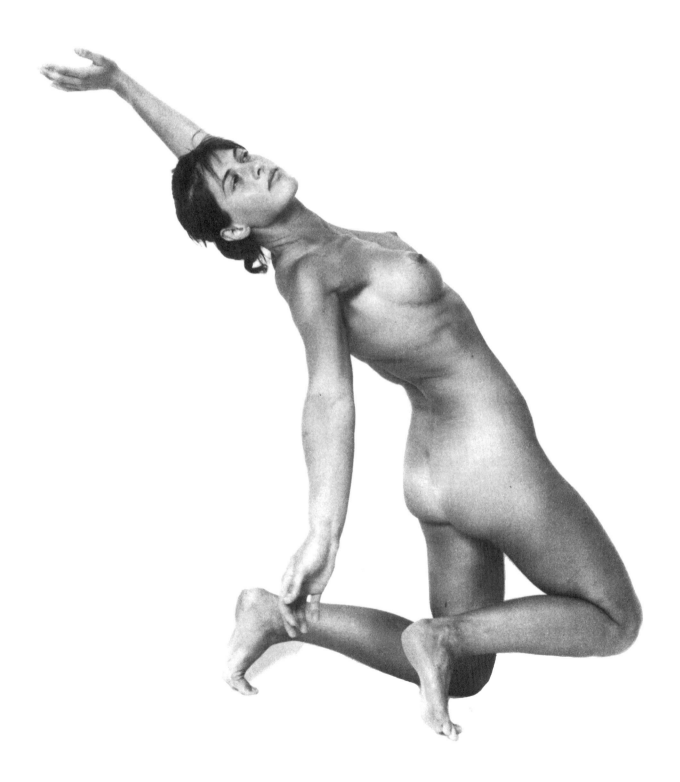

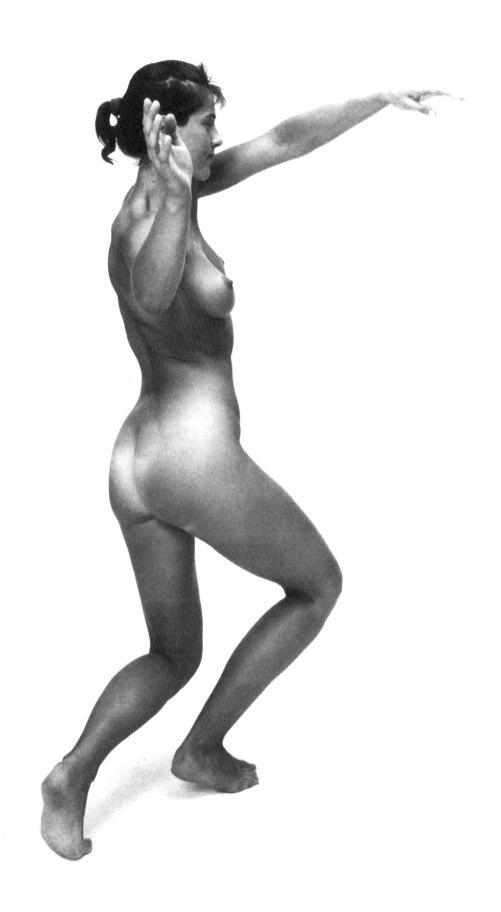

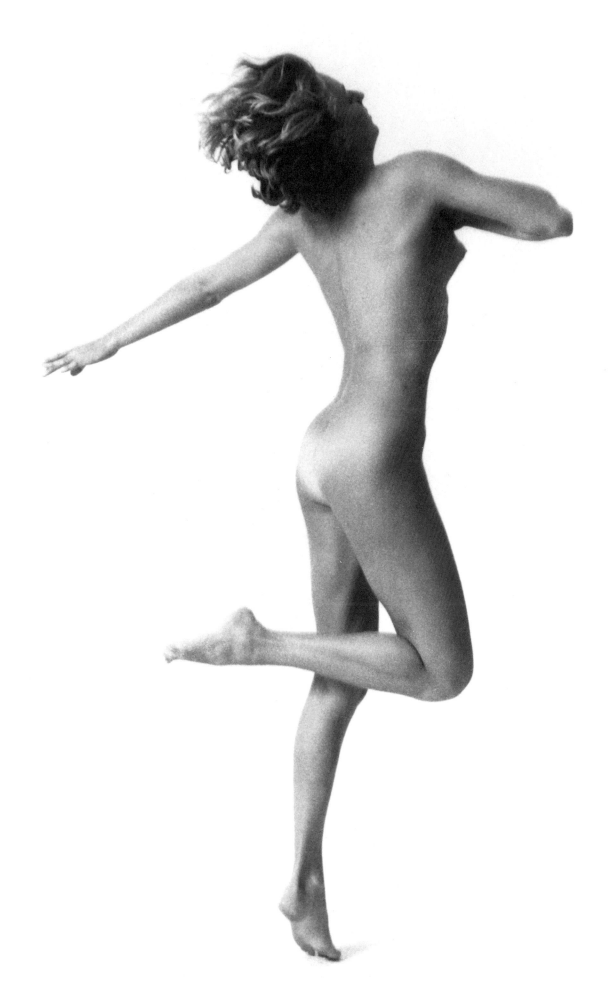

83

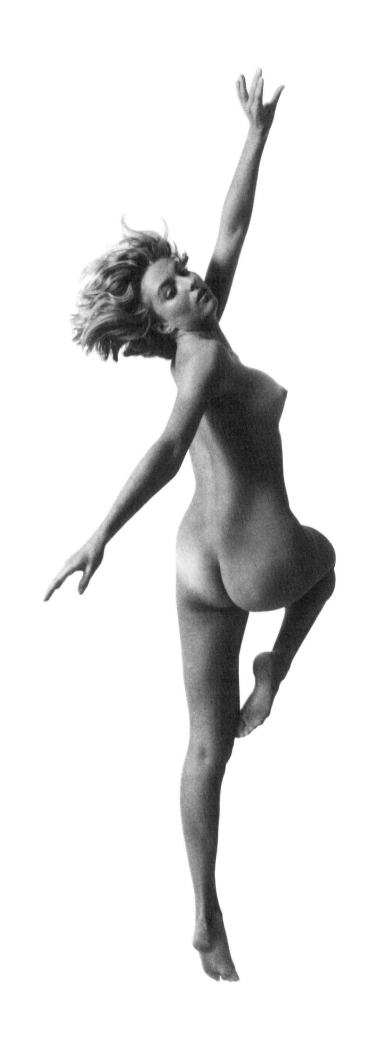

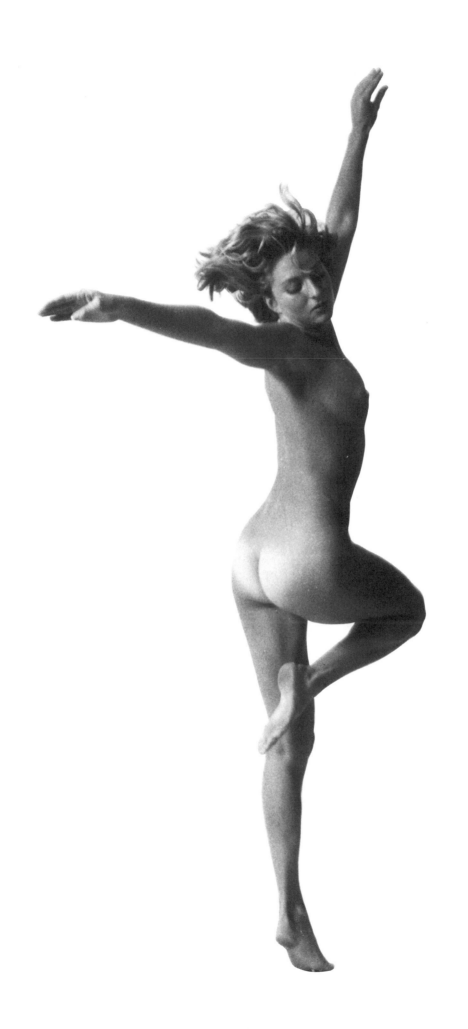

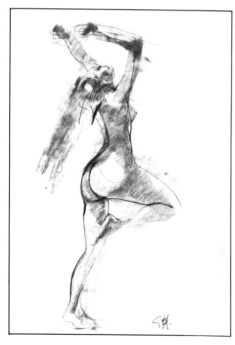

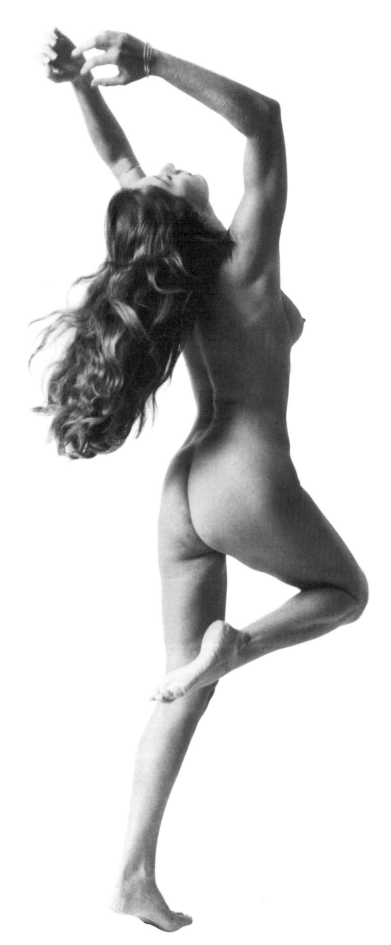

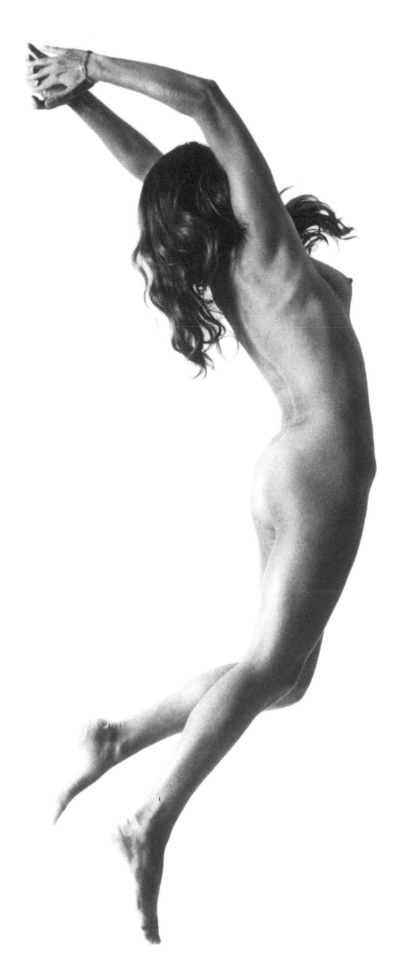
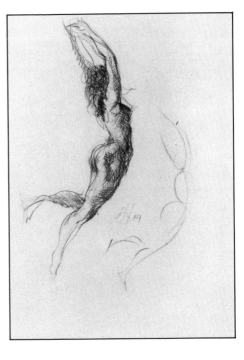

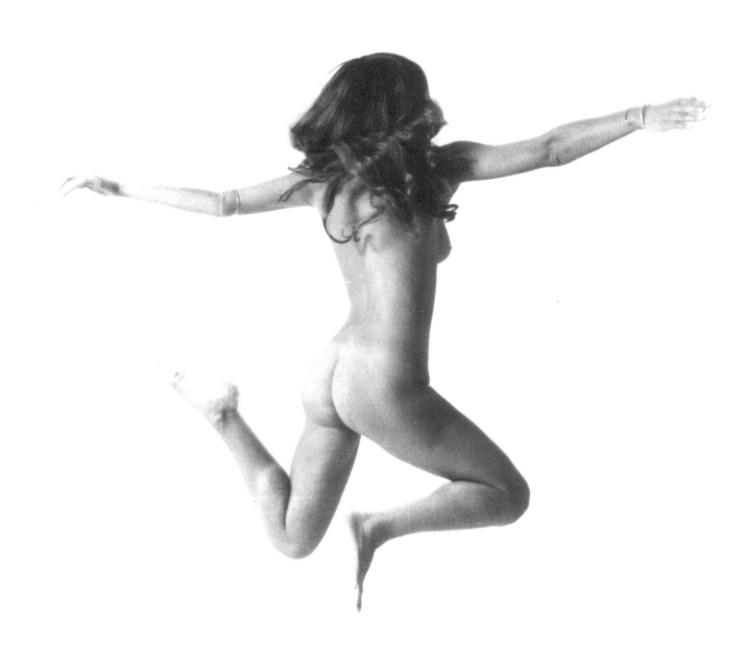

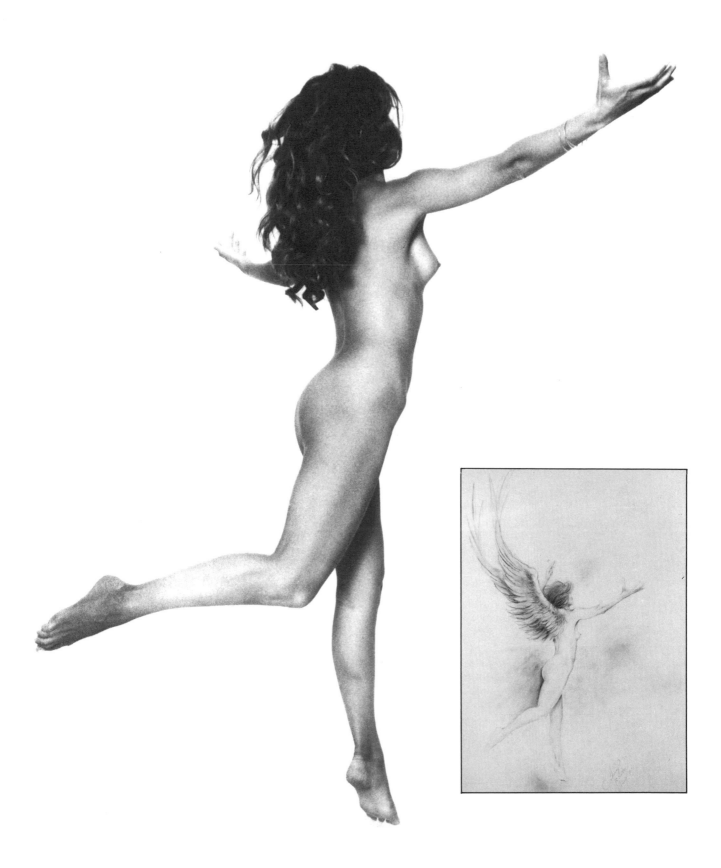

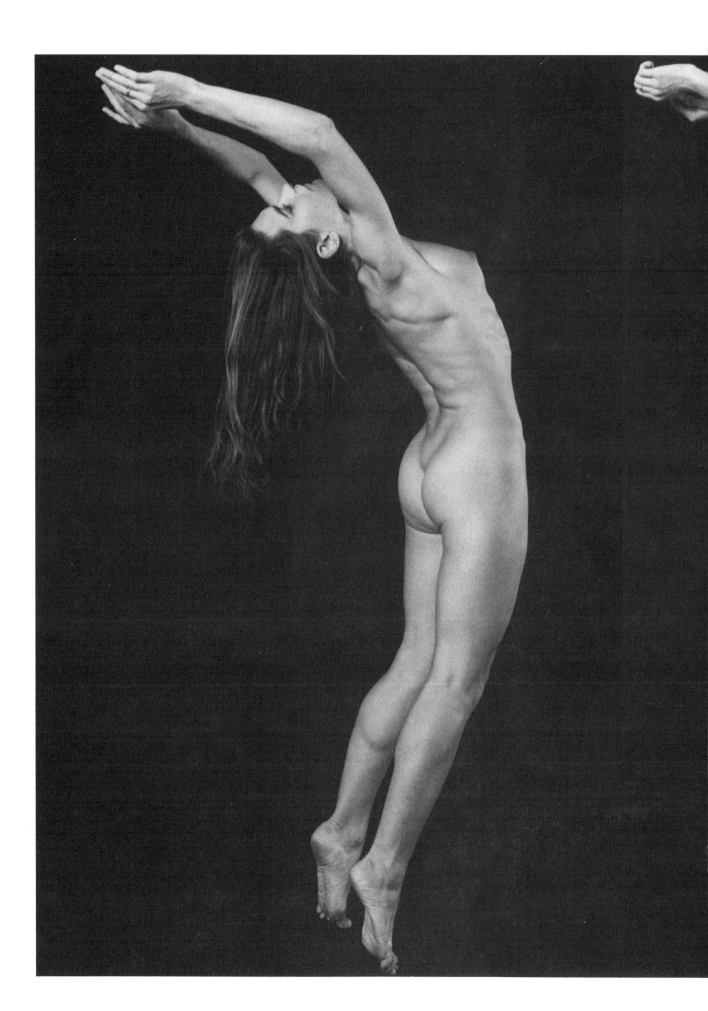

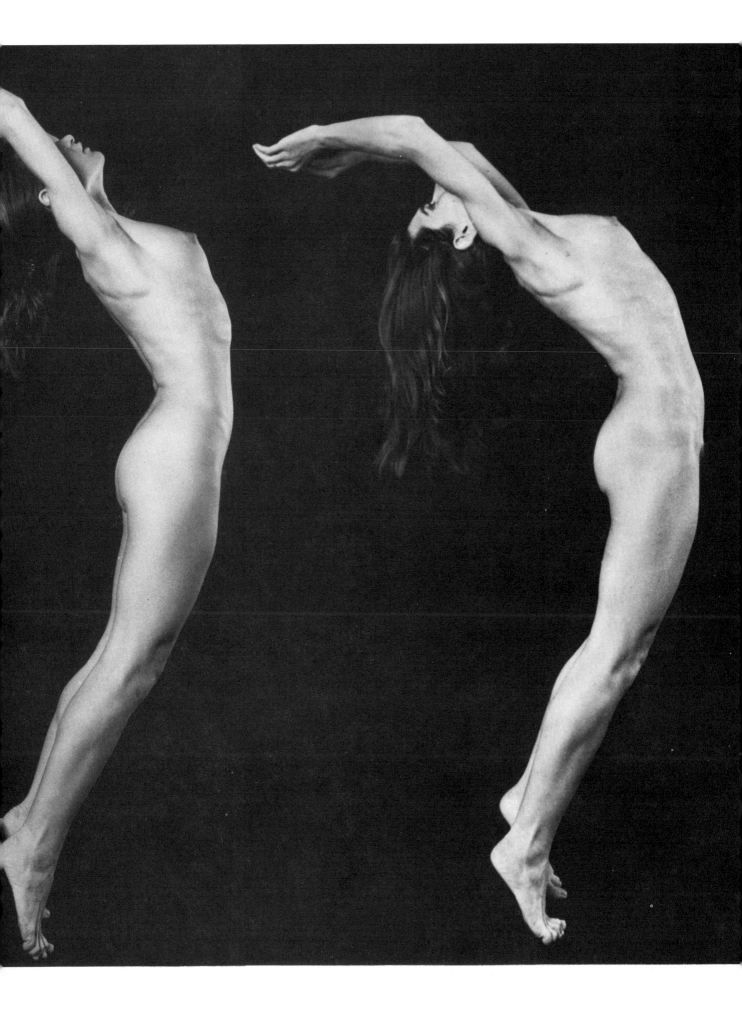

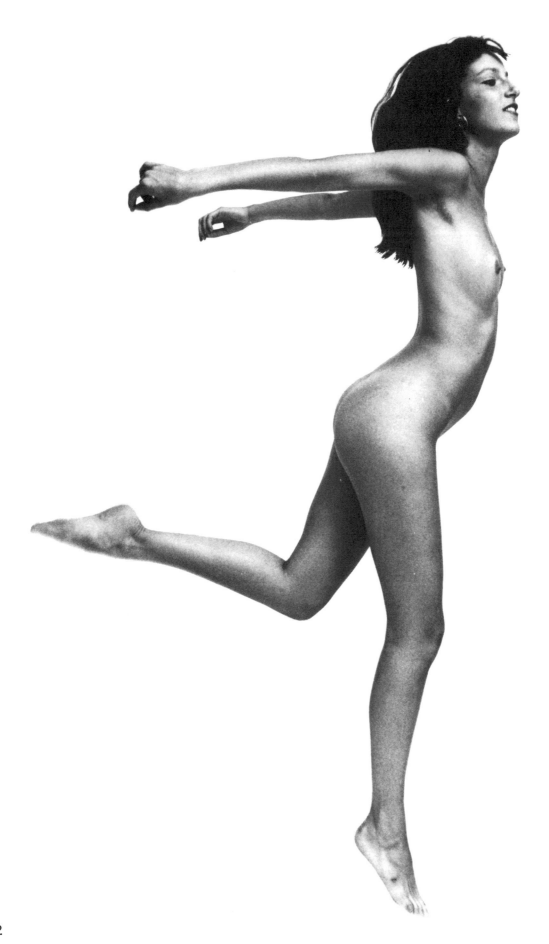

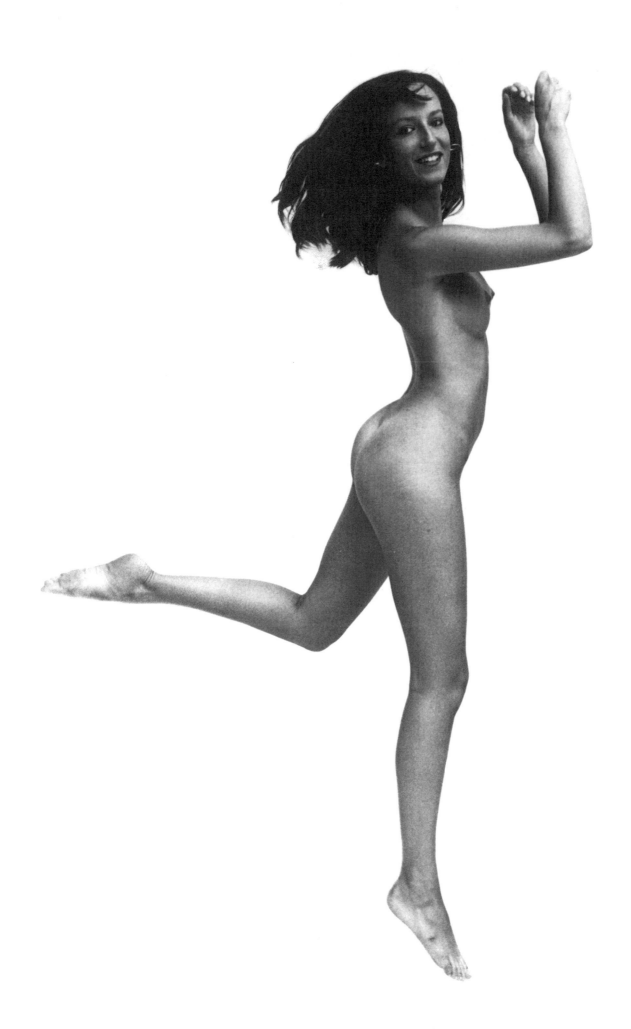

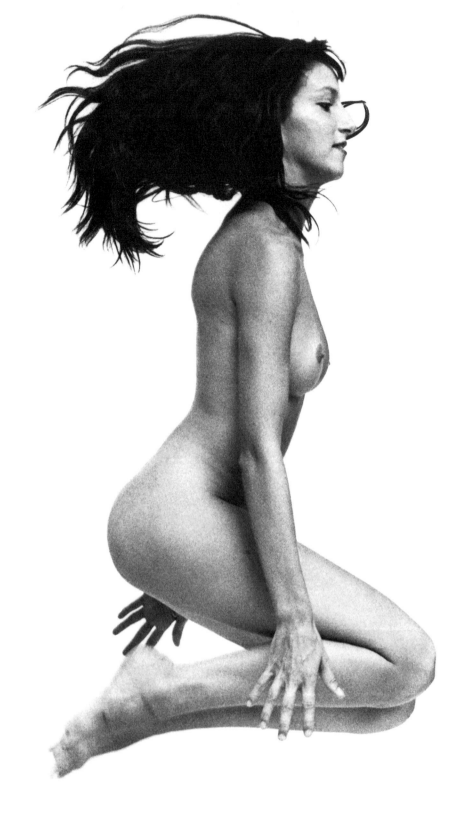

94

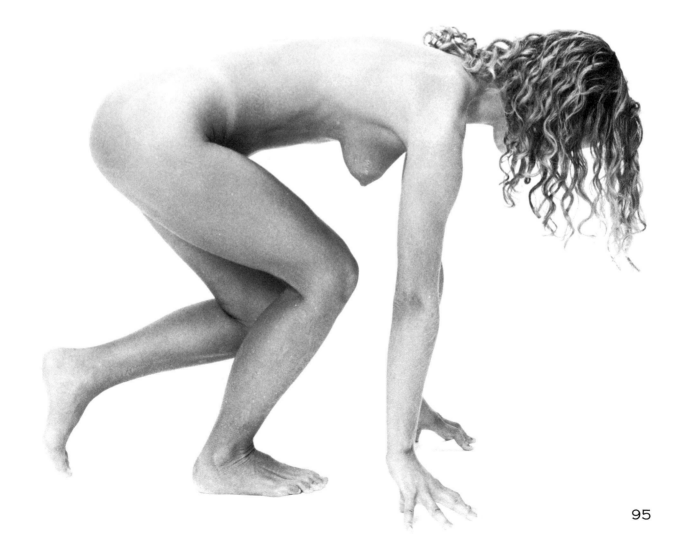

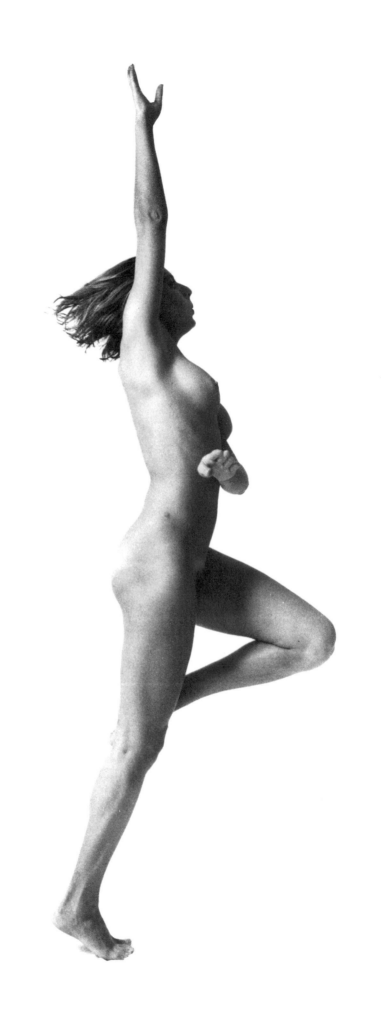

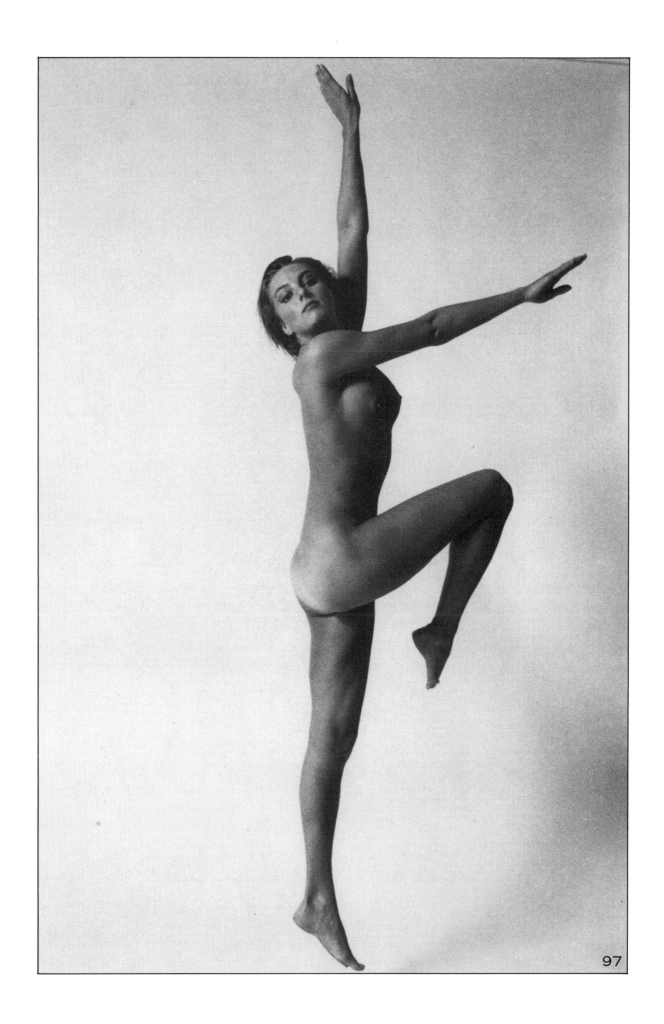

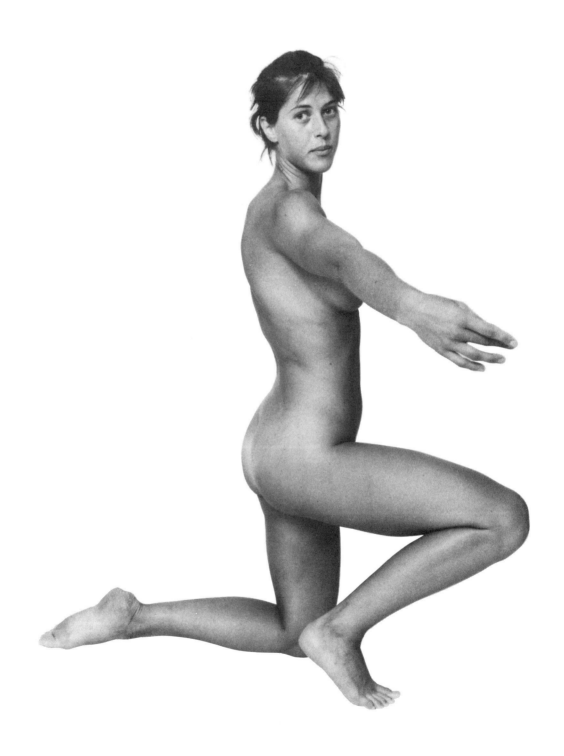

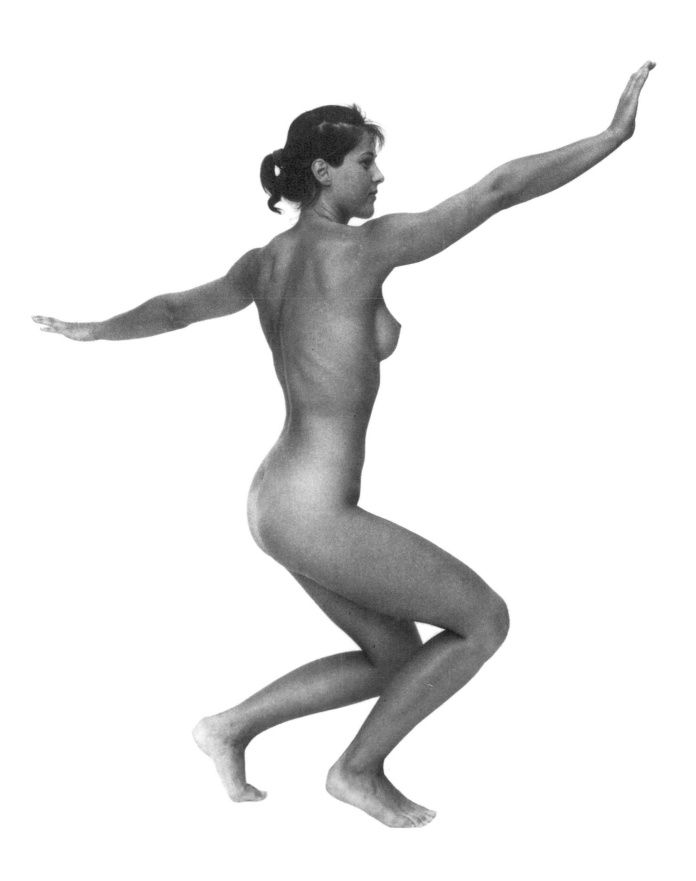

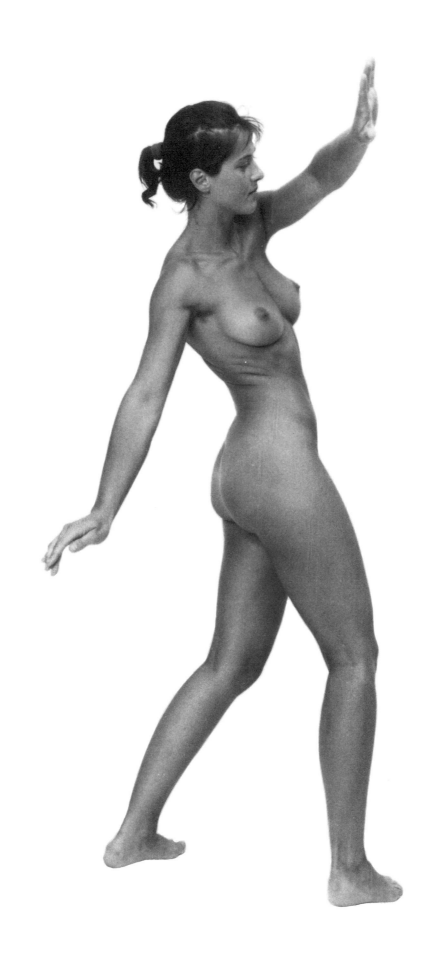

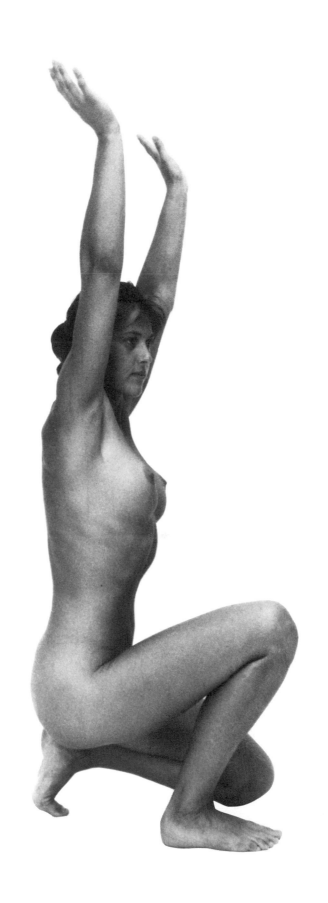

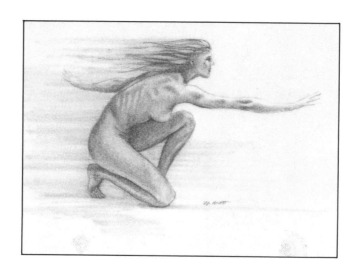

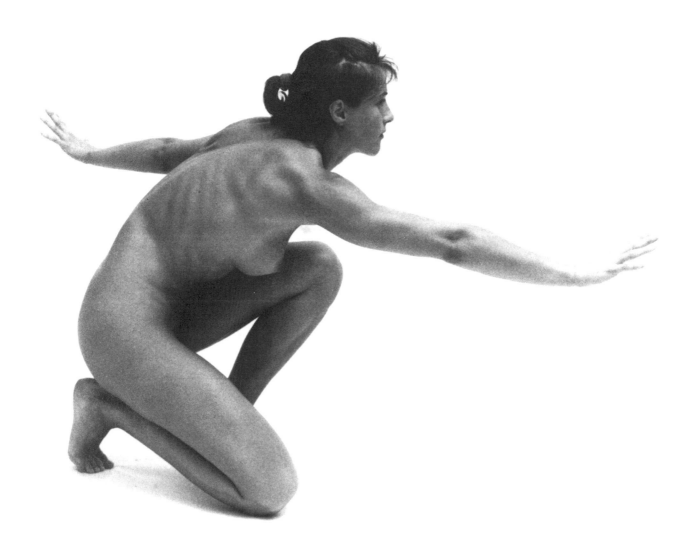

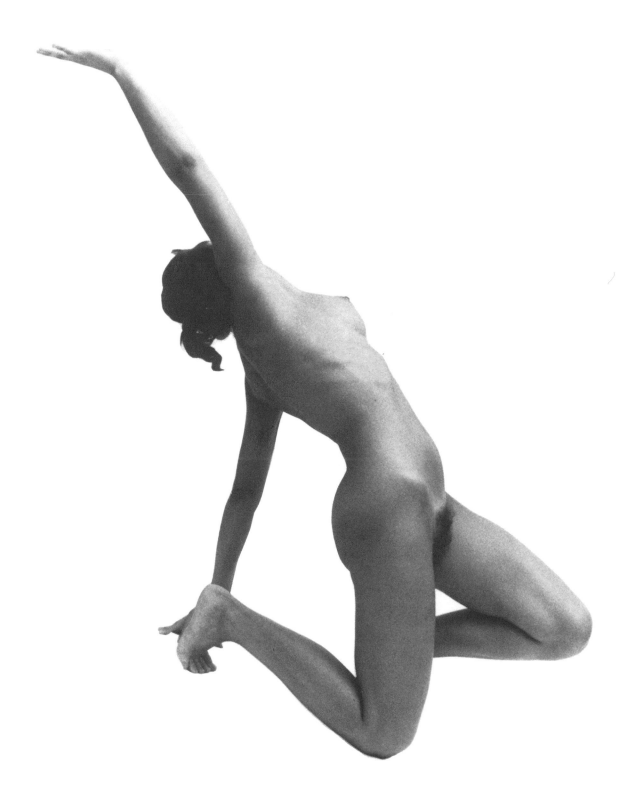

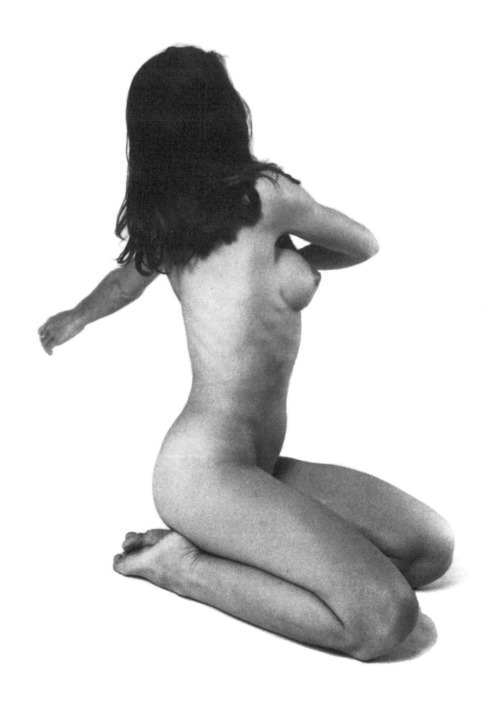

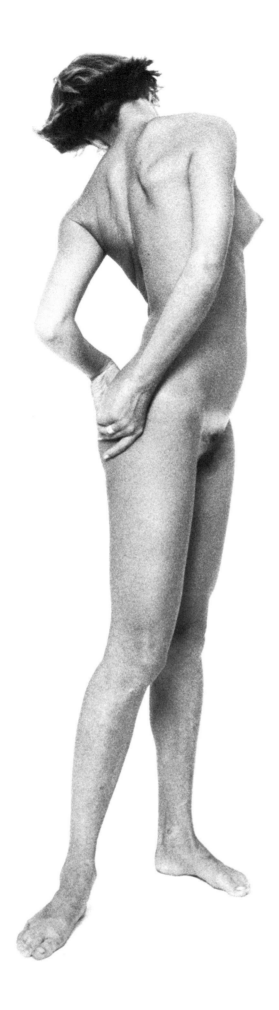

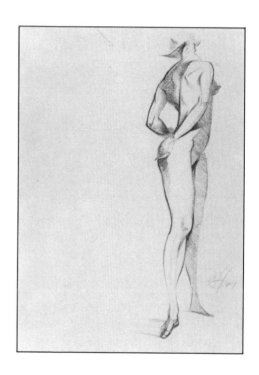

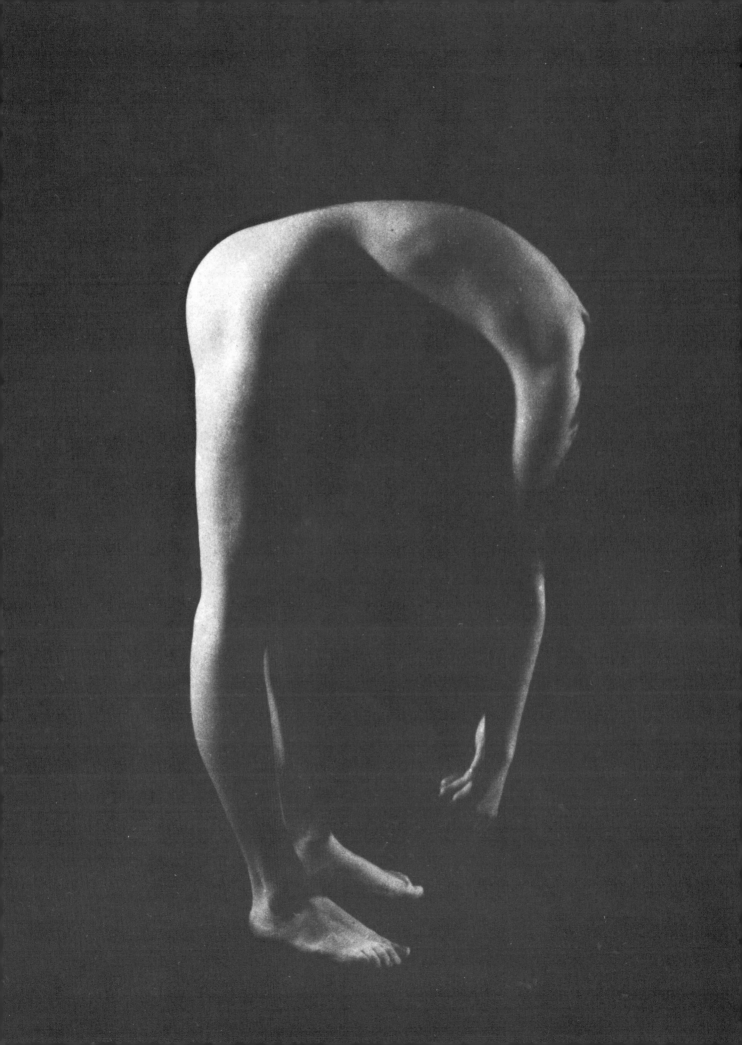

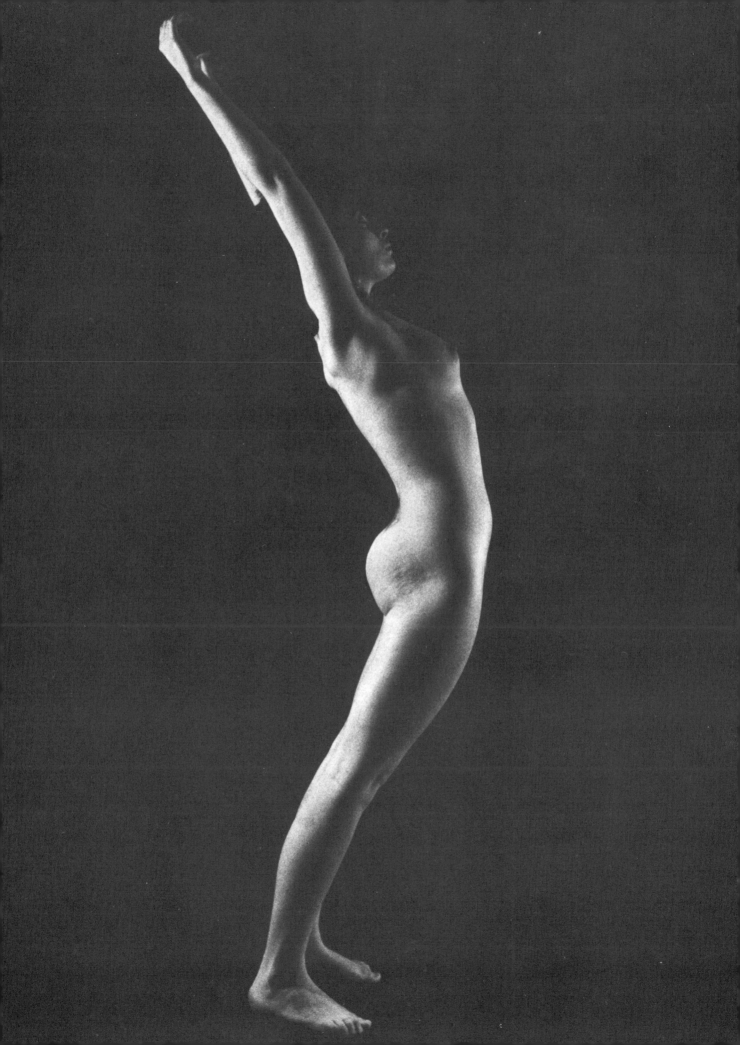

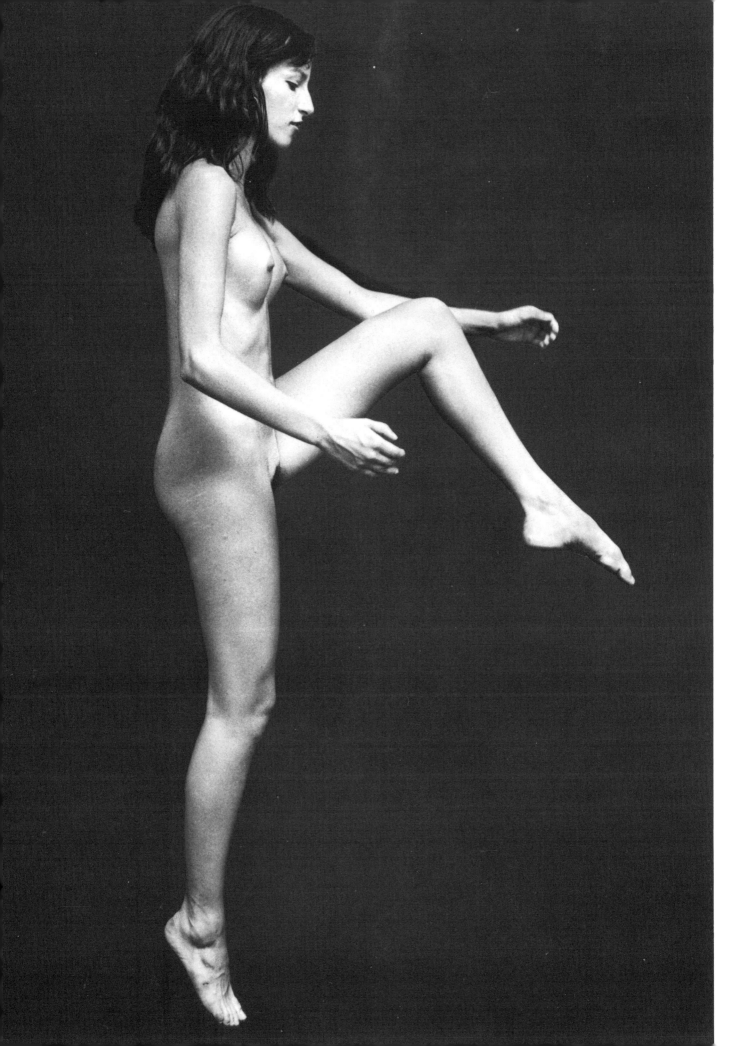

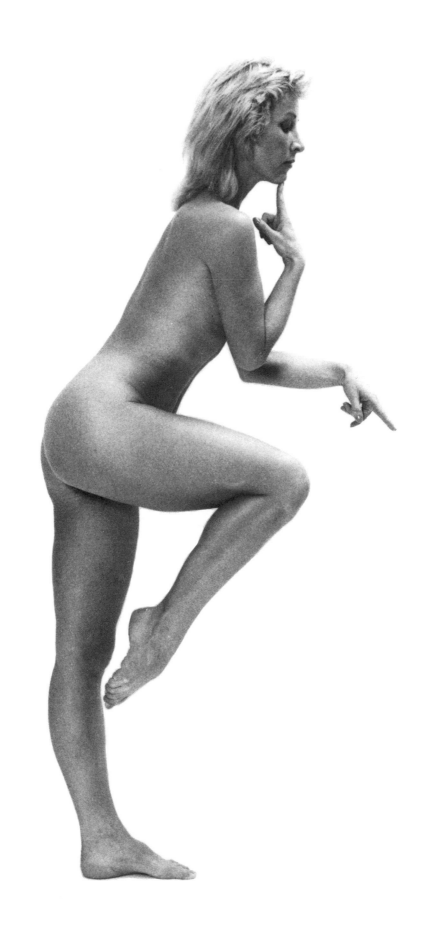

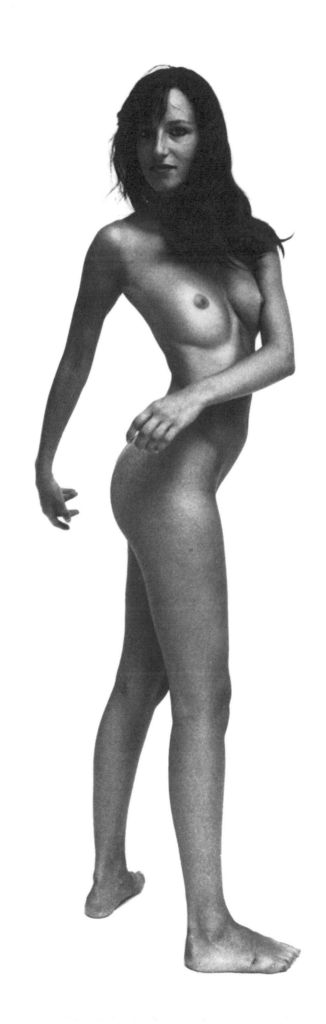

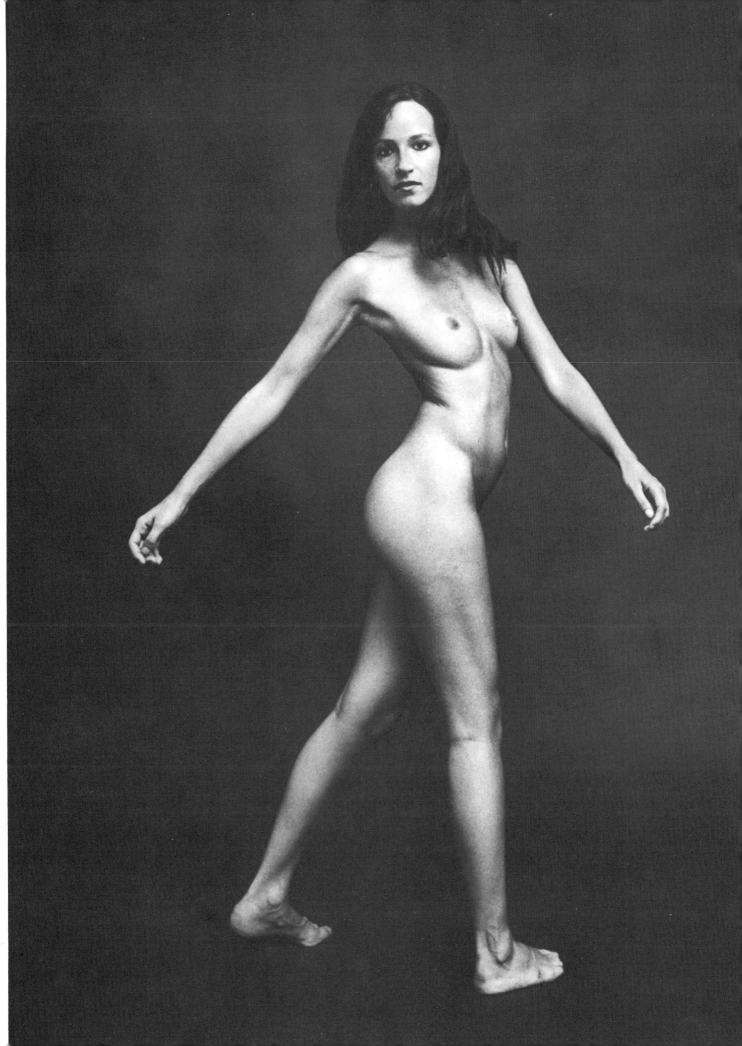

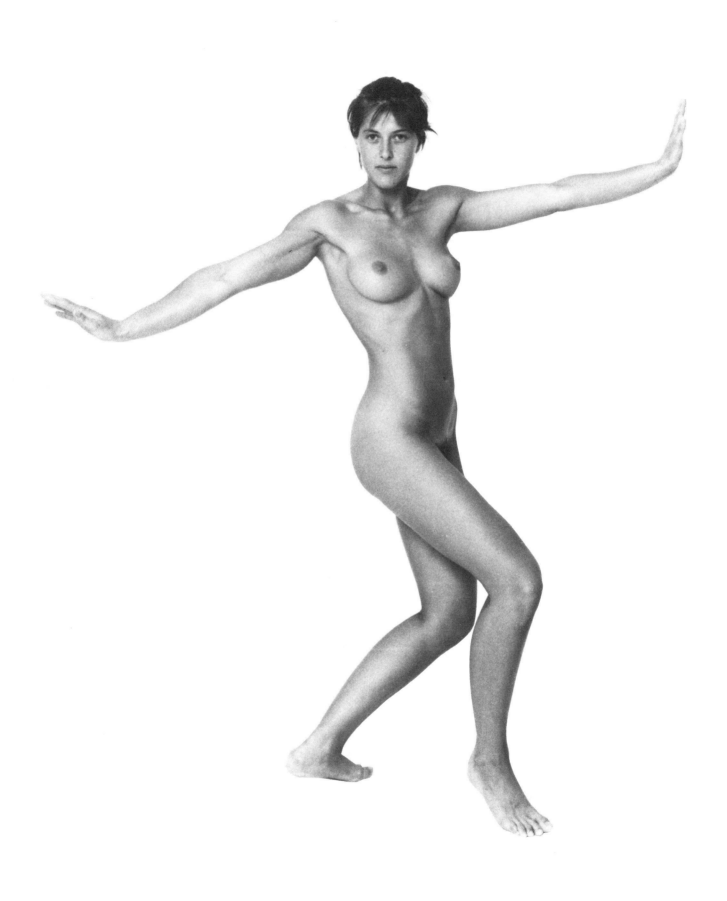

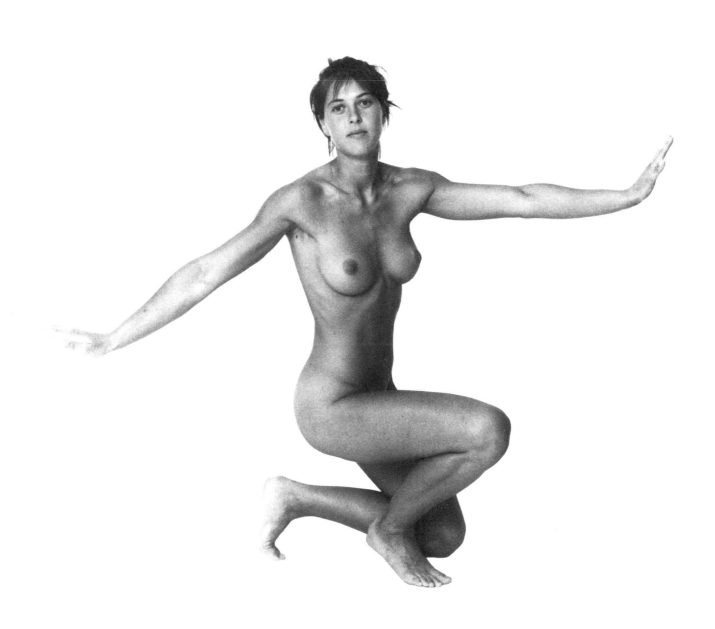

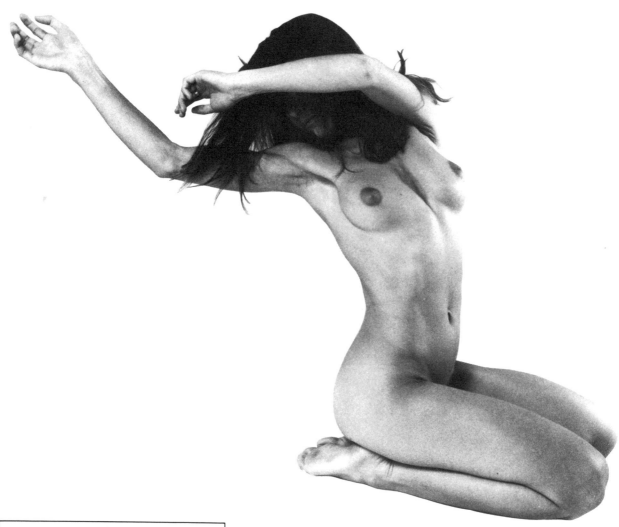

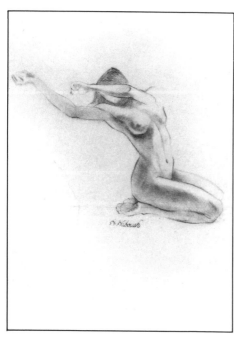

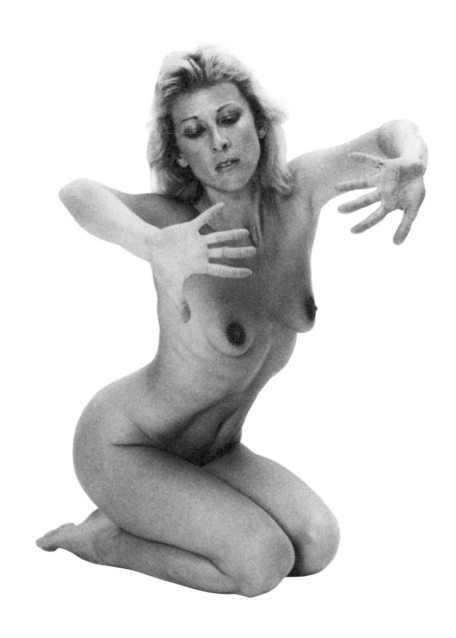

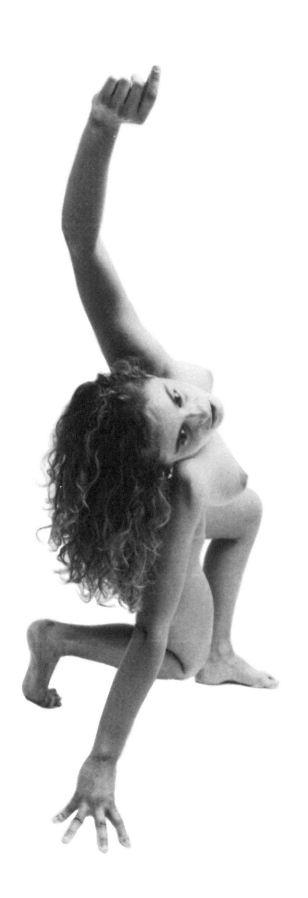
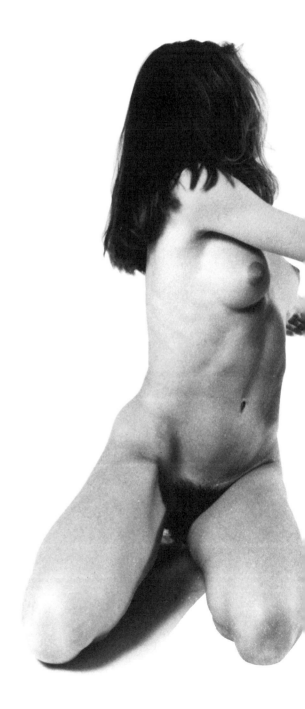

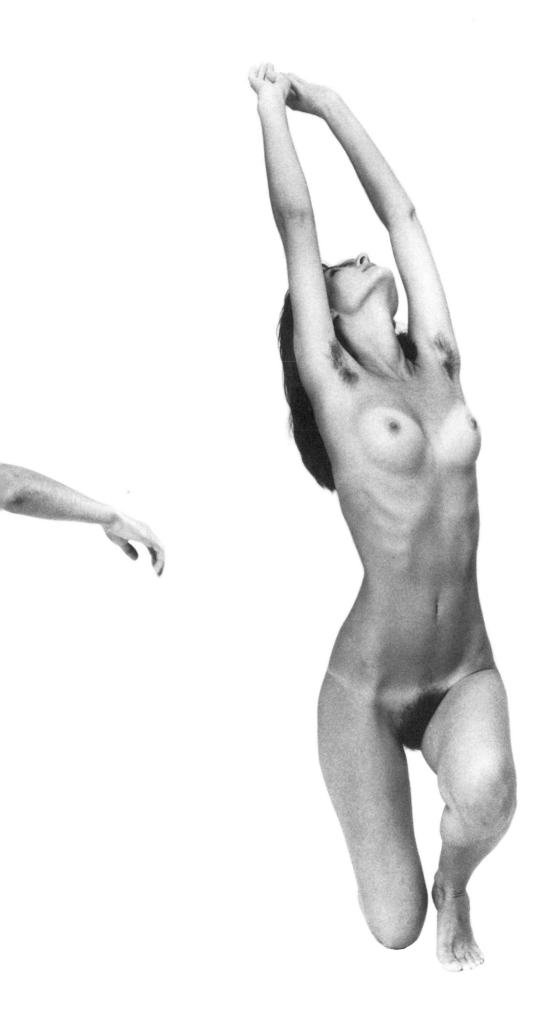

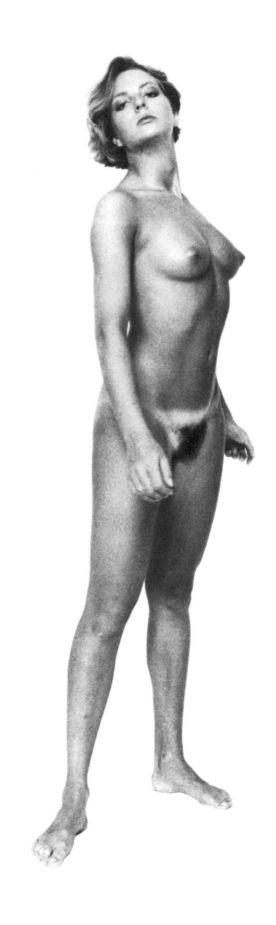

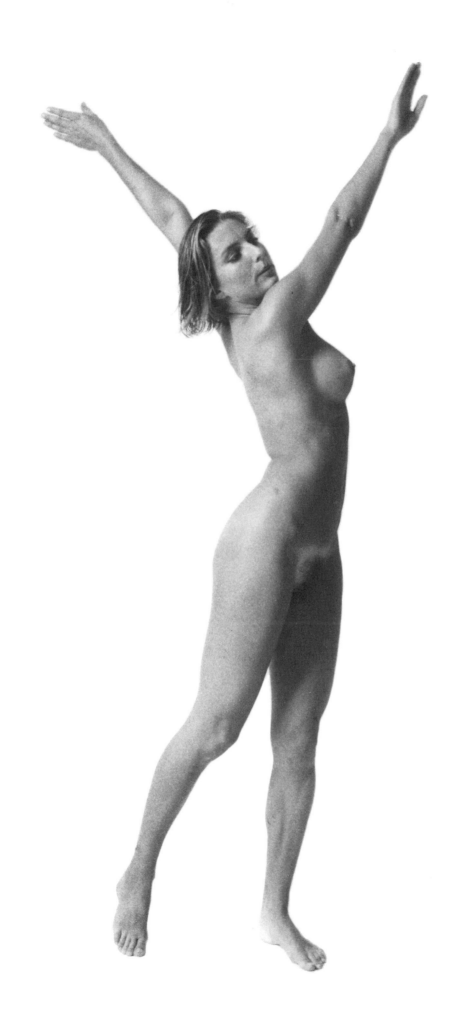

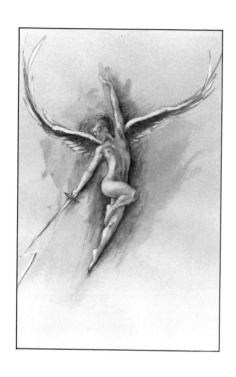

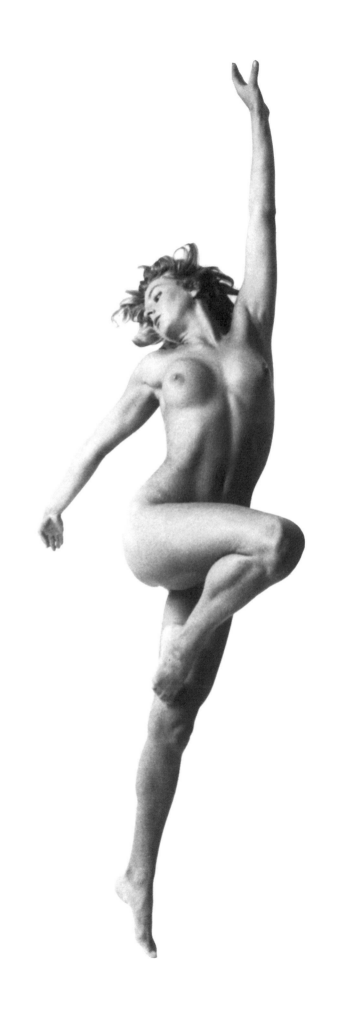

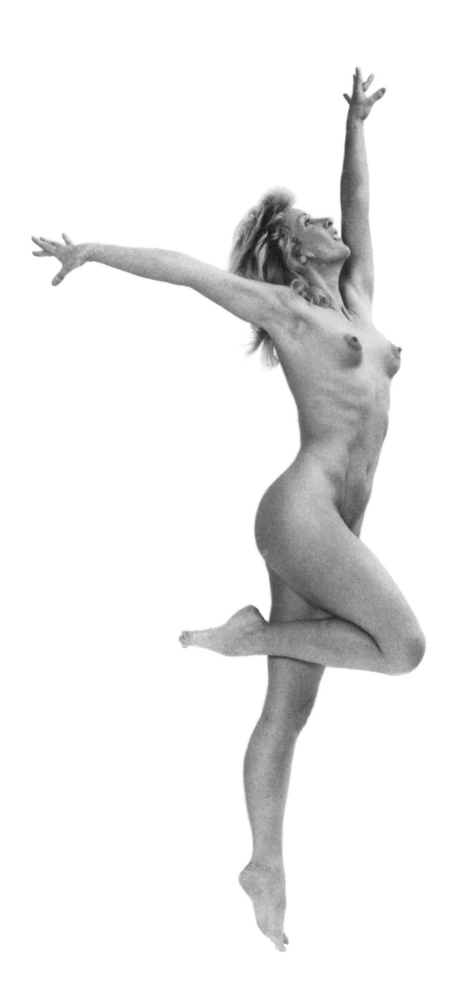

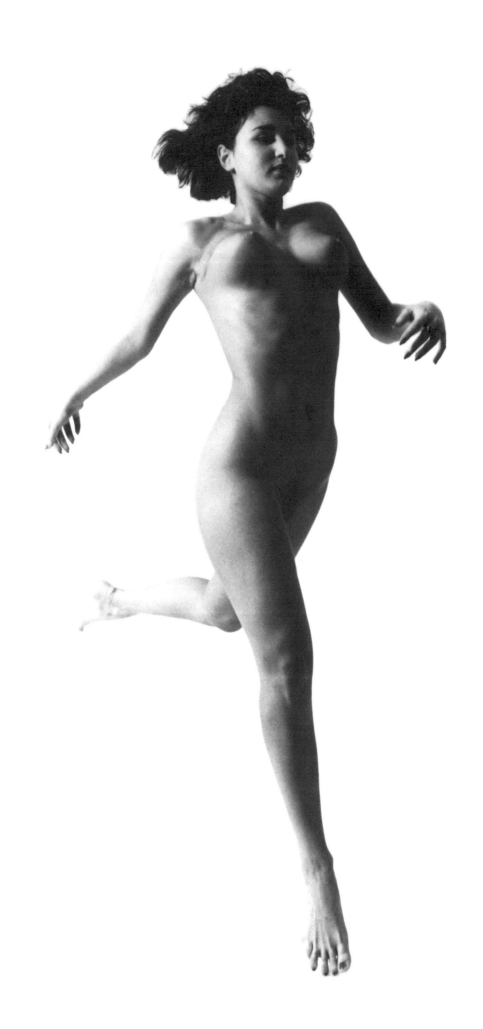

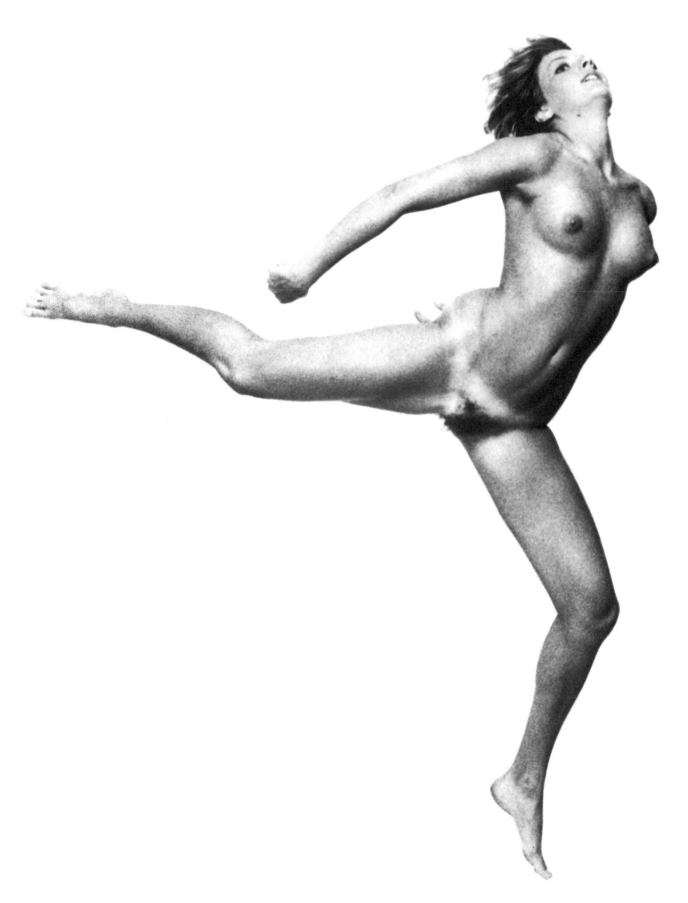

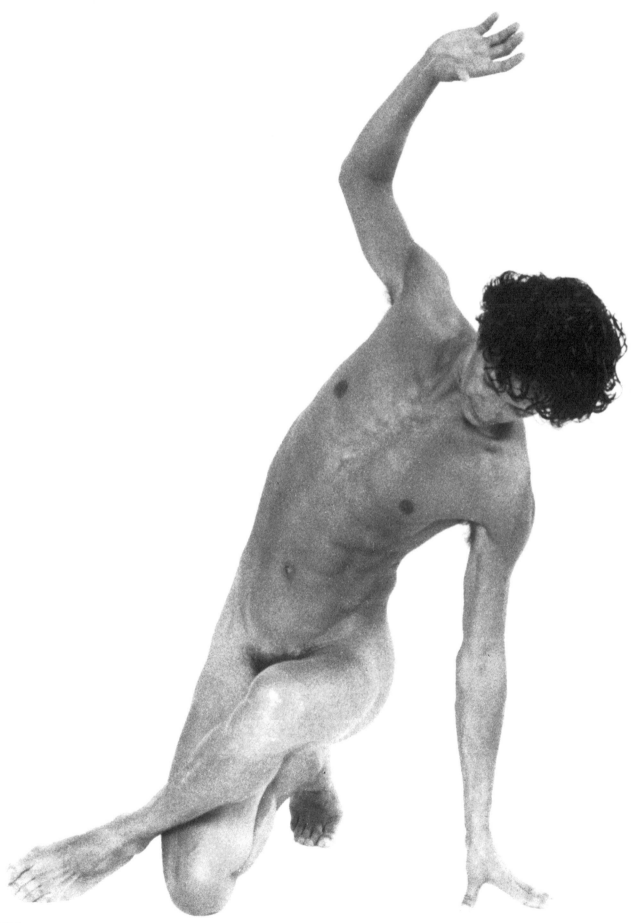

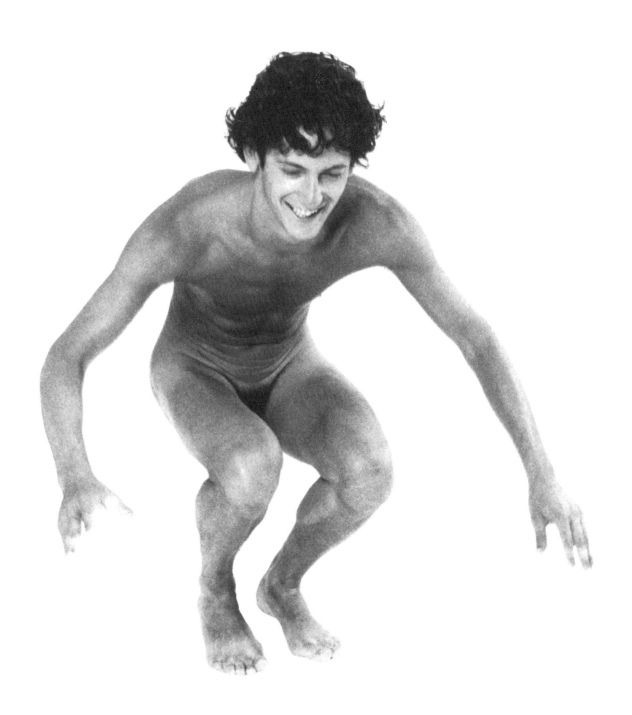

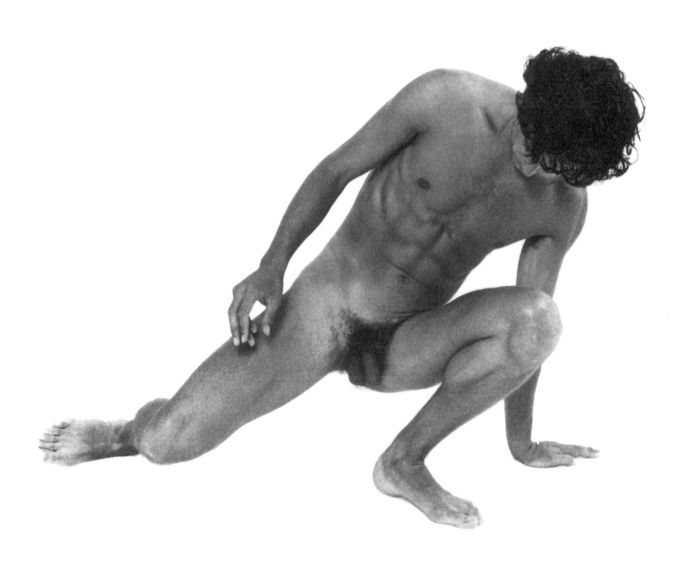

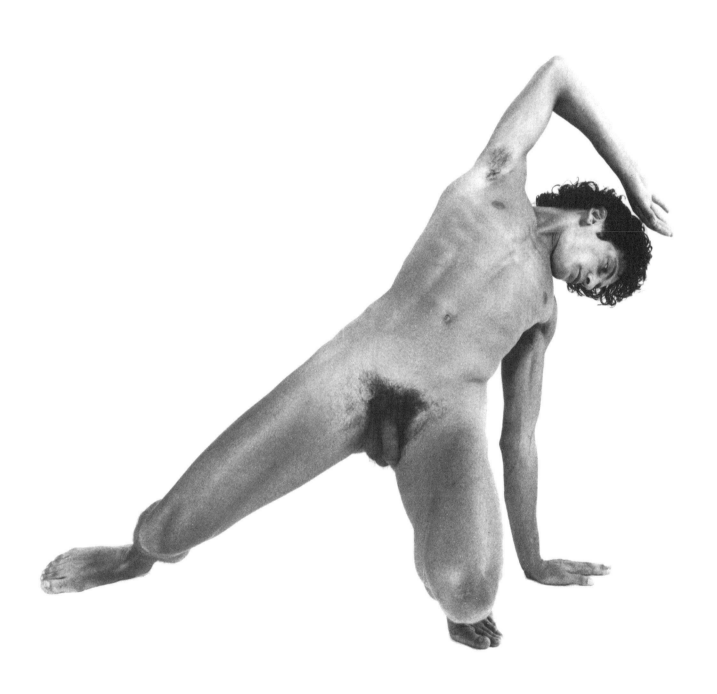

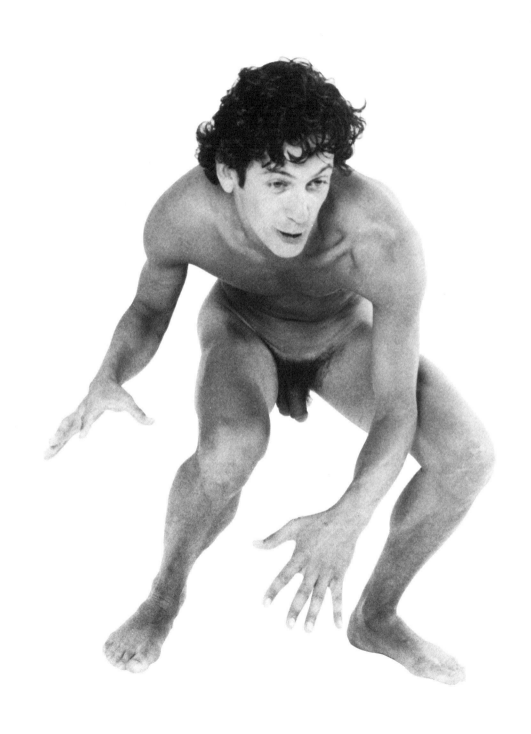

128

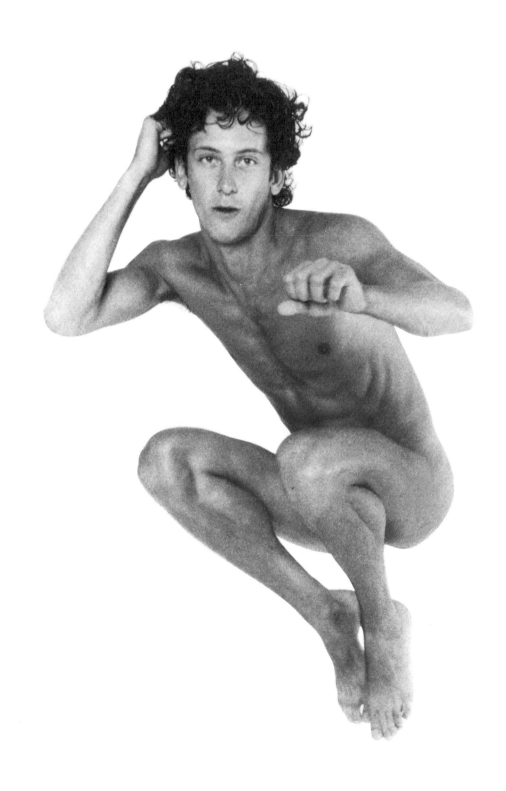

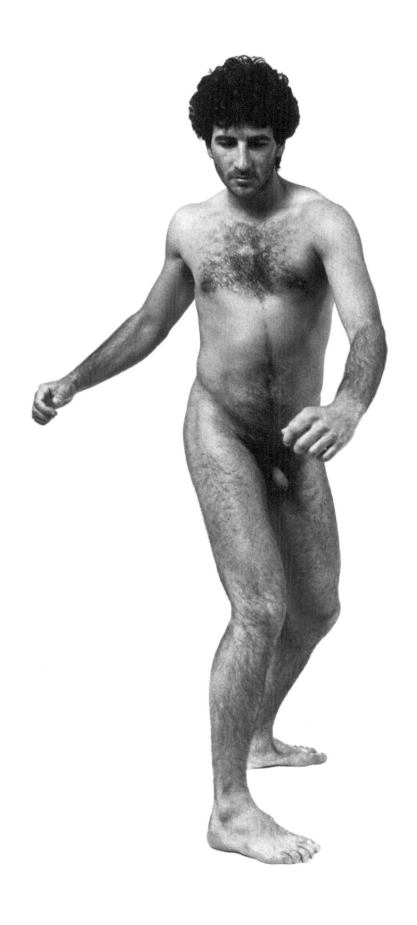

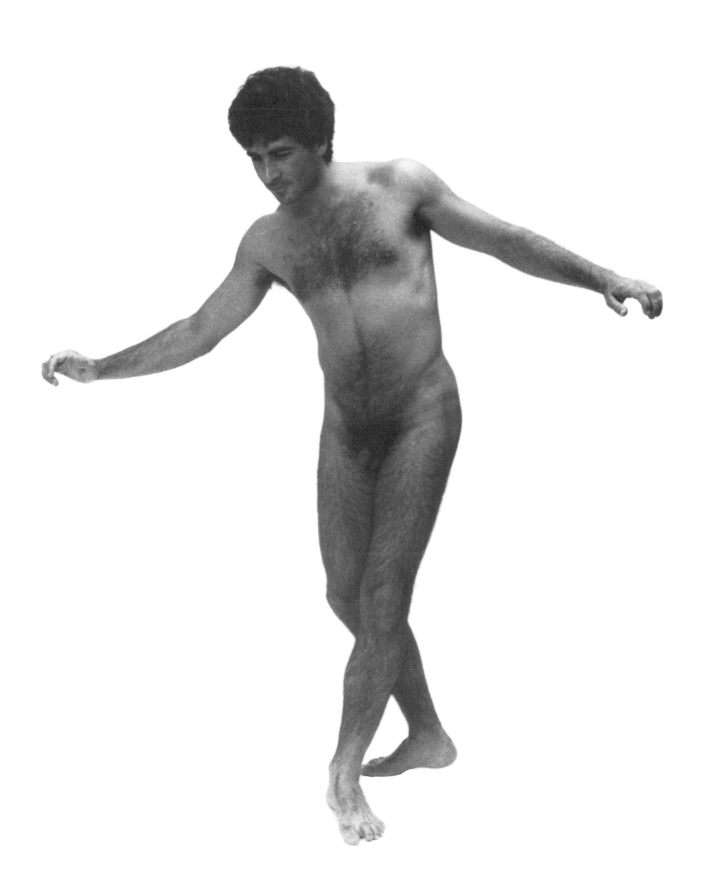

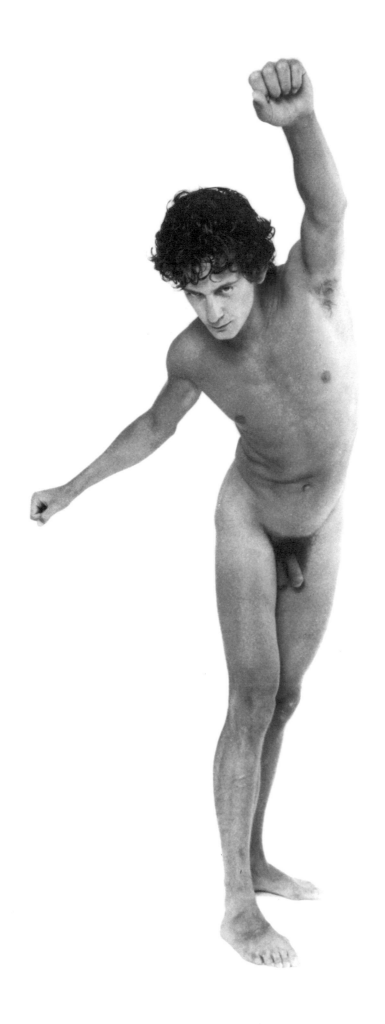

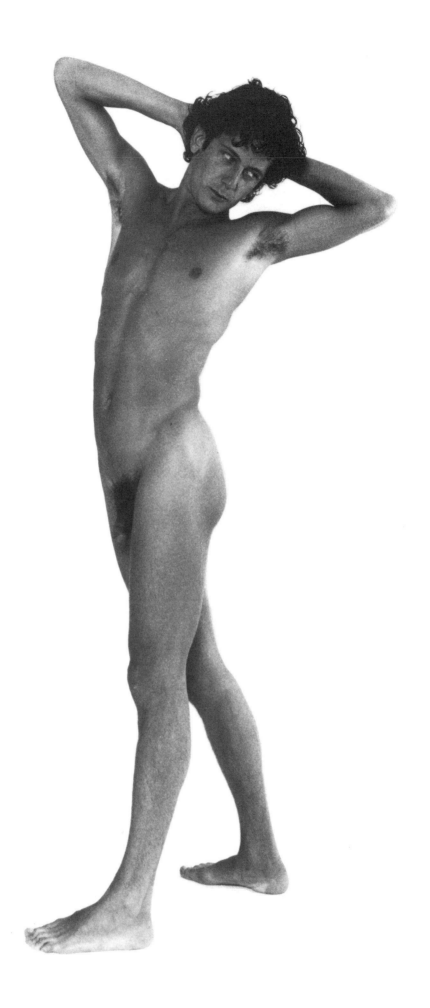

133

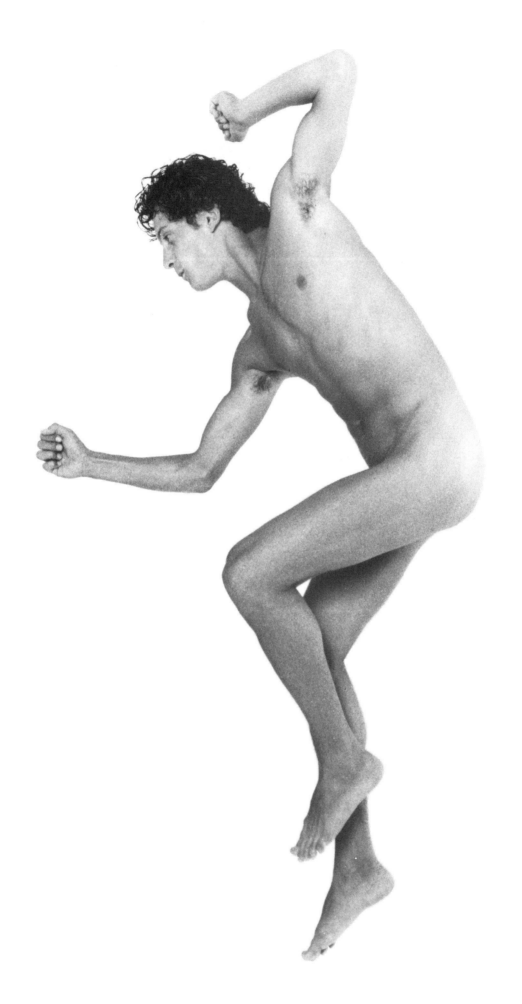

134

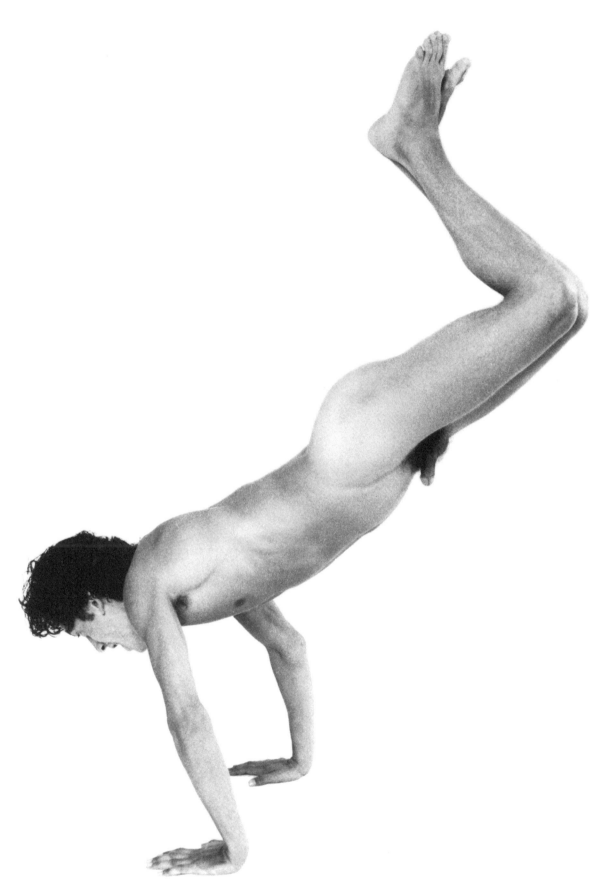

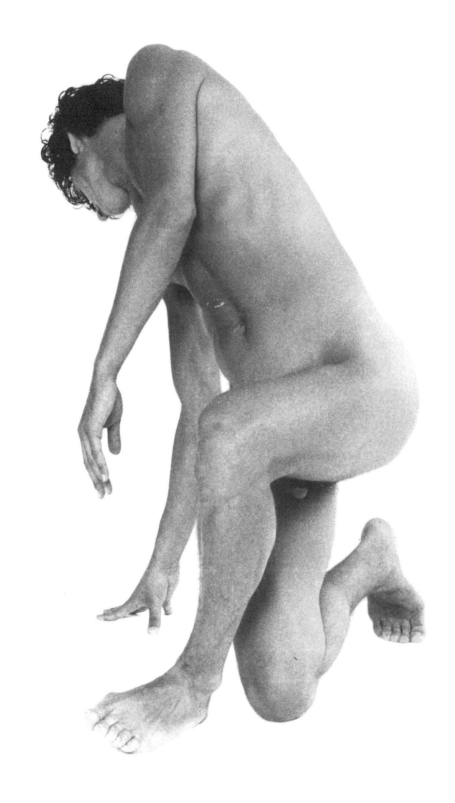

136

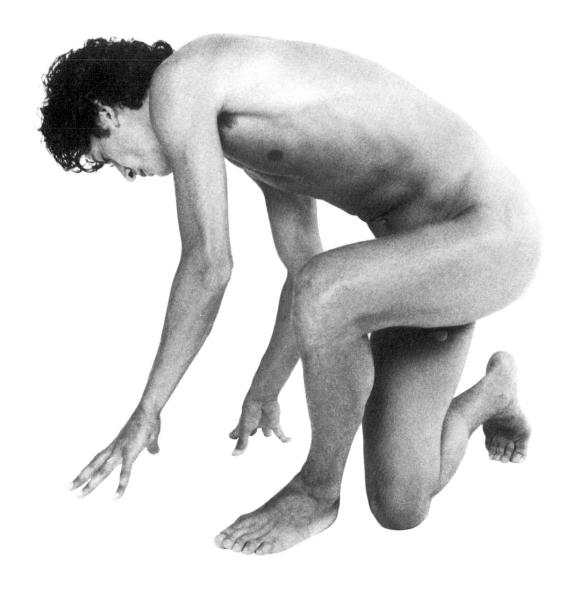

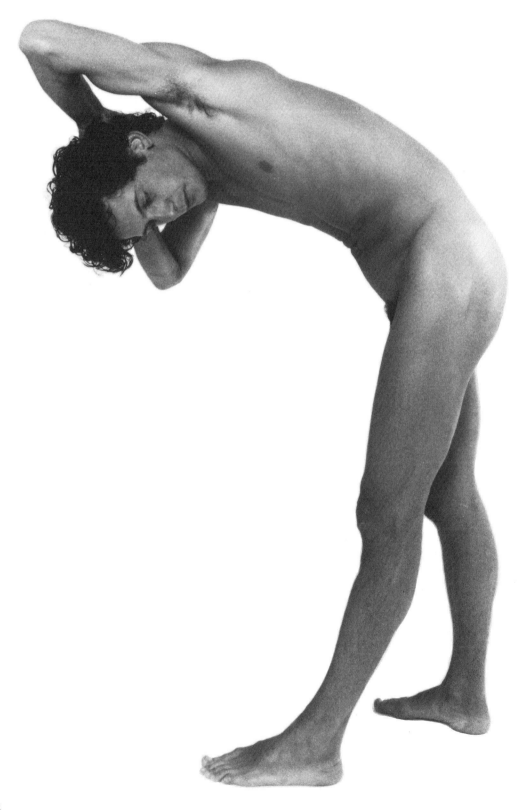

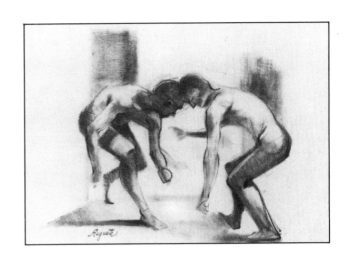

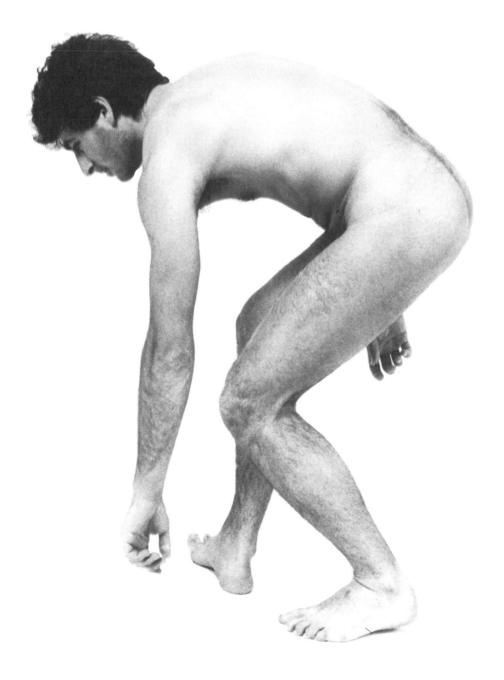

139

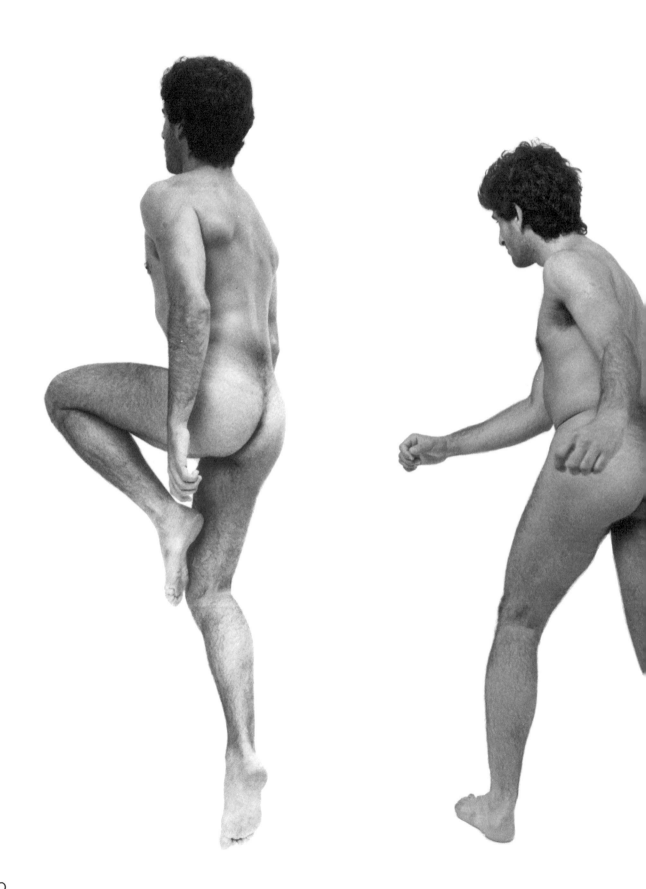

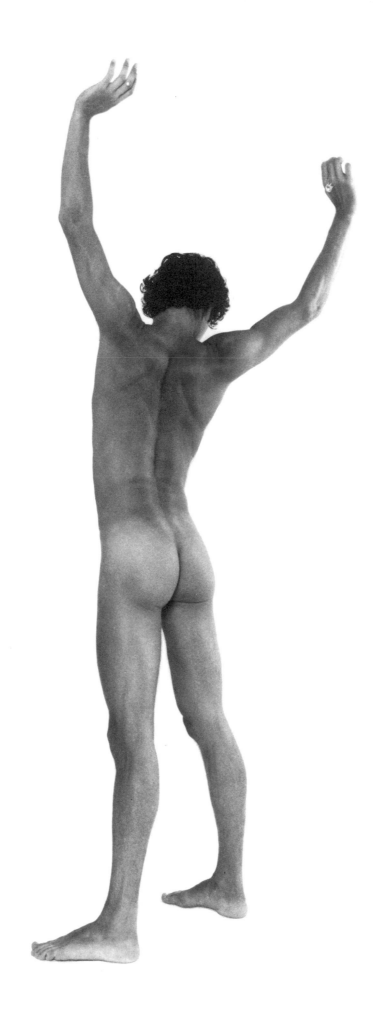

141

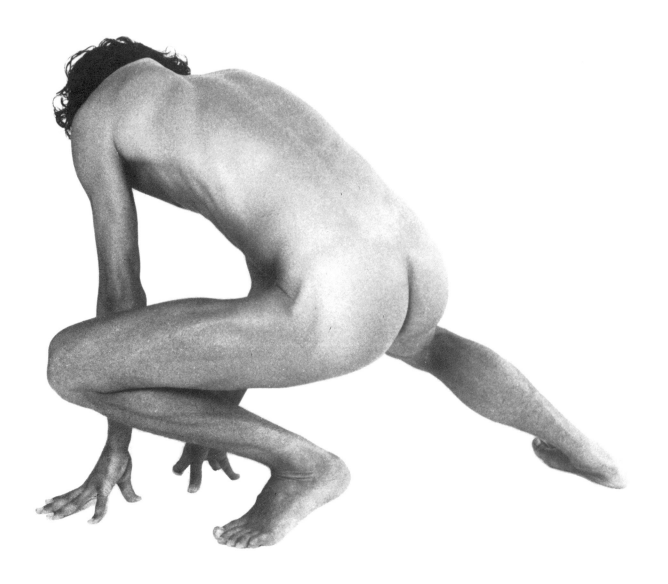

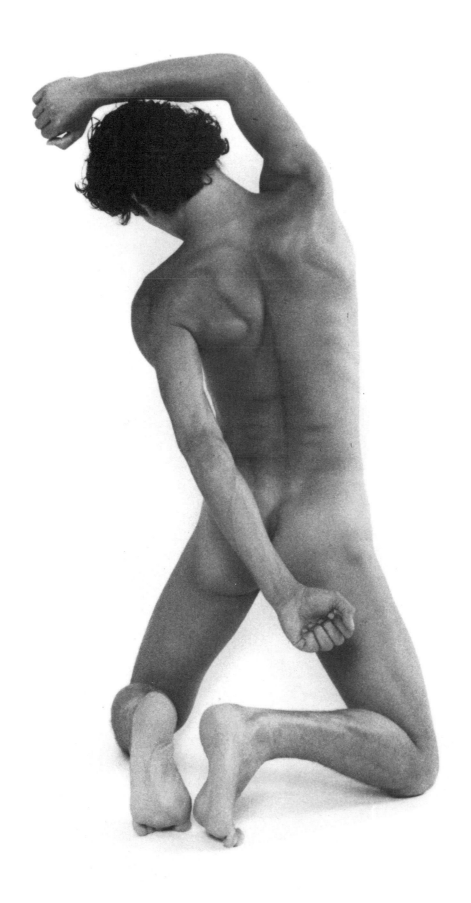

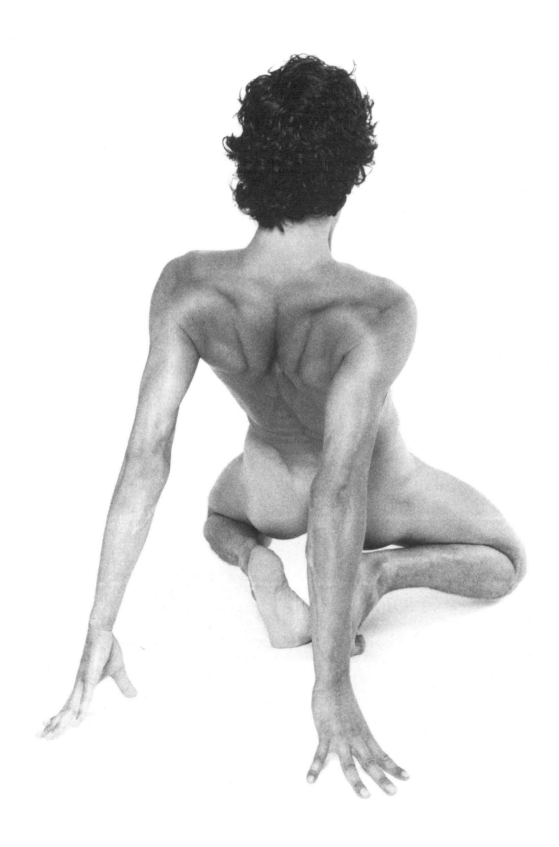

144

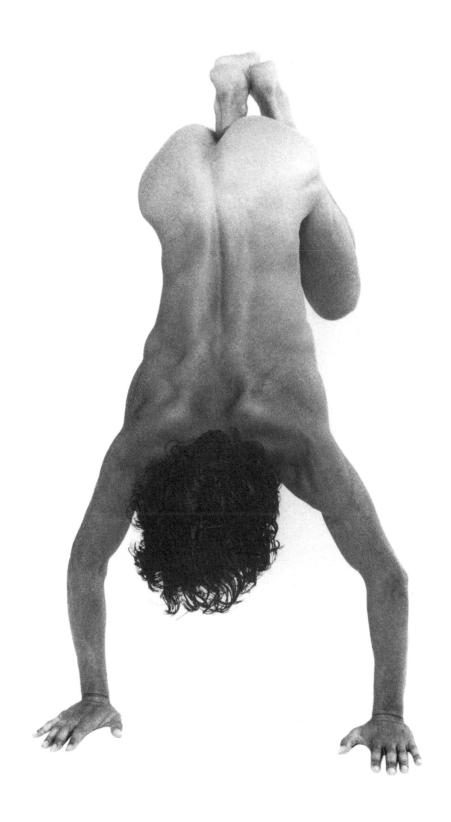

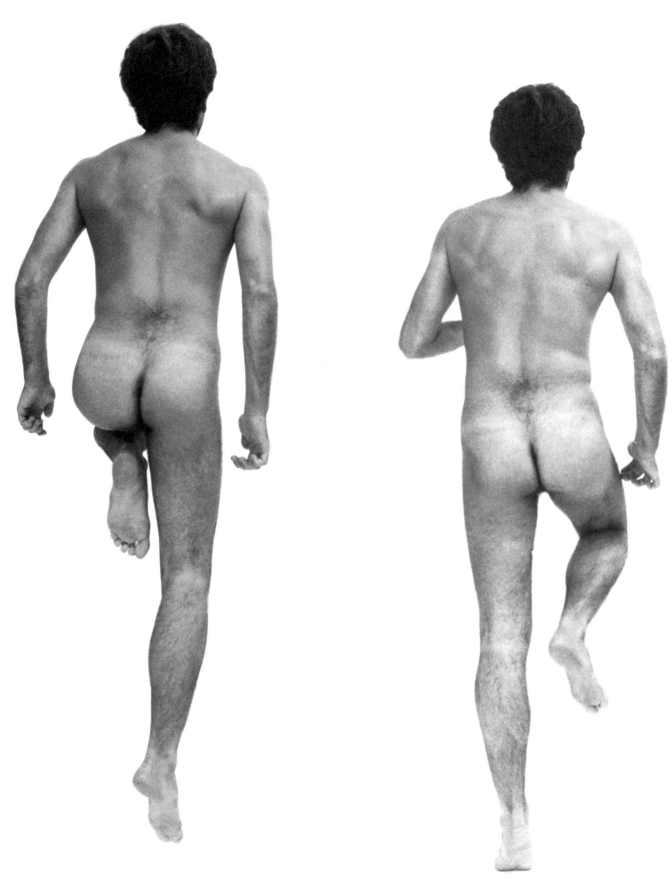

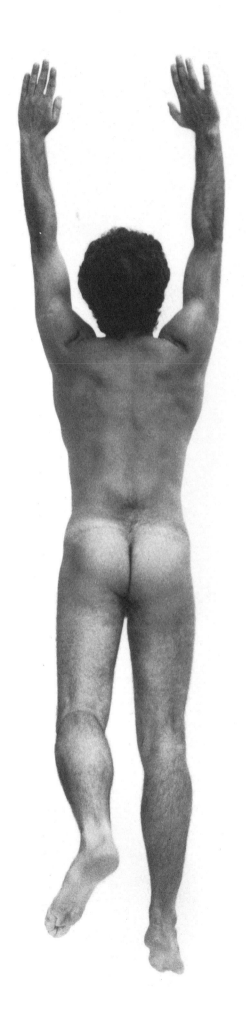

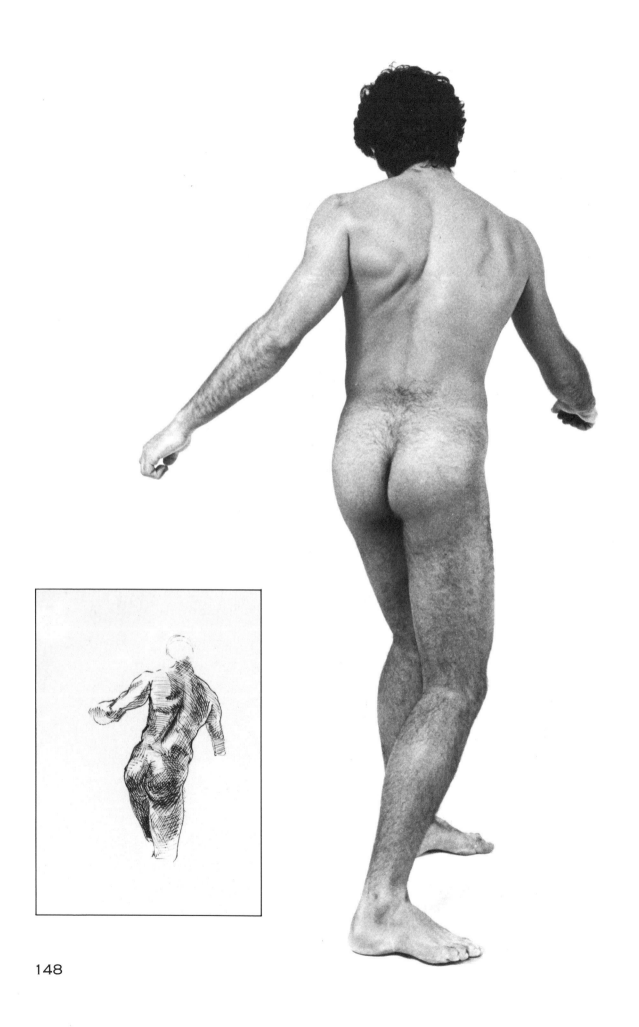

148

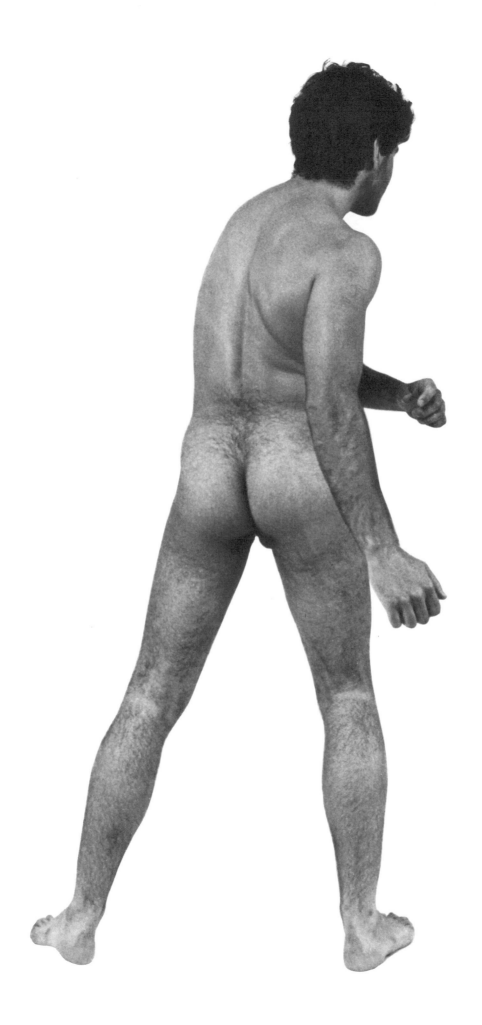

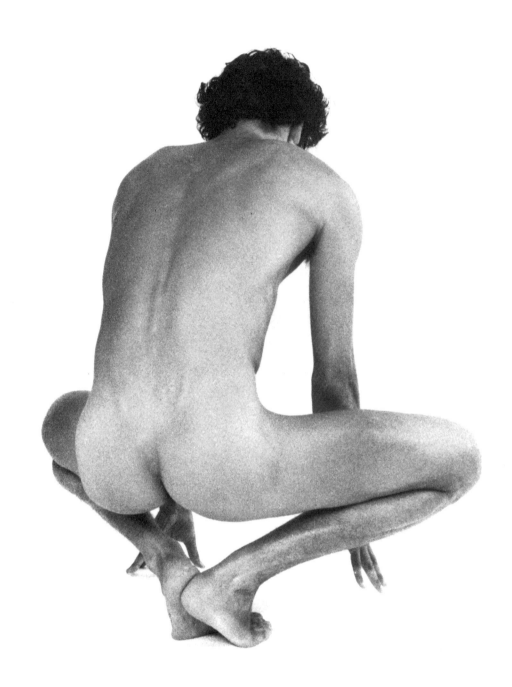

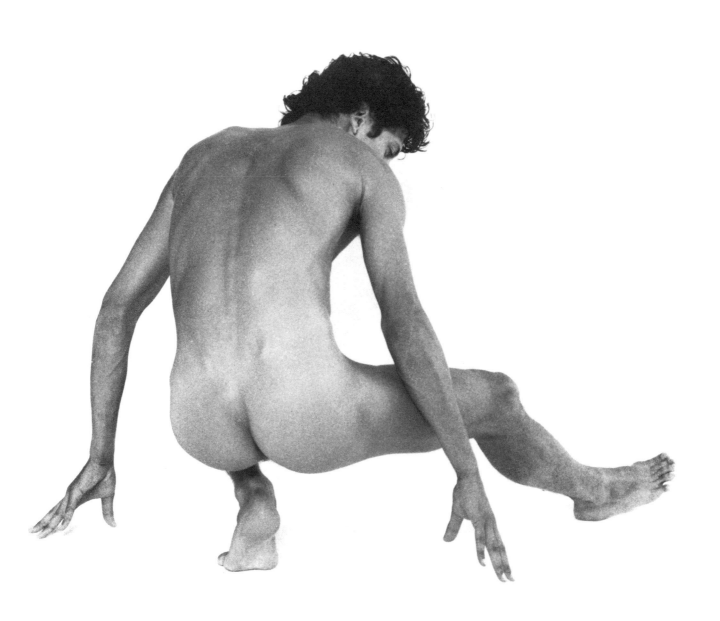

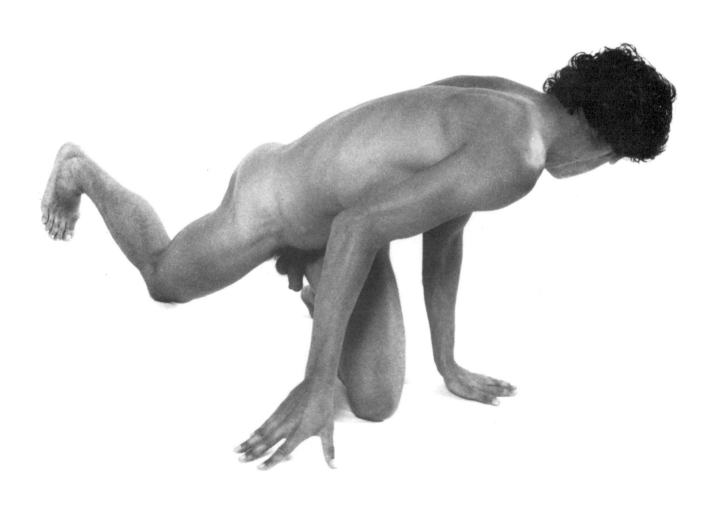

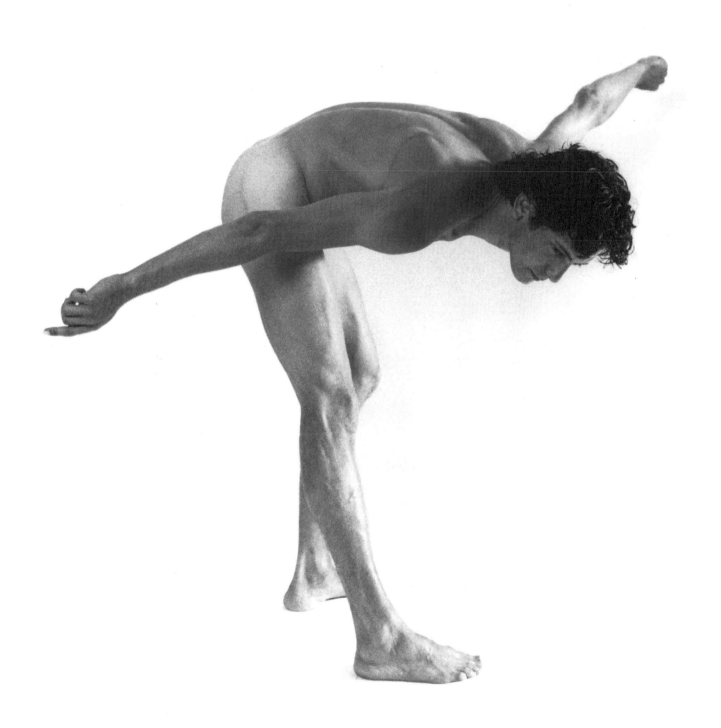

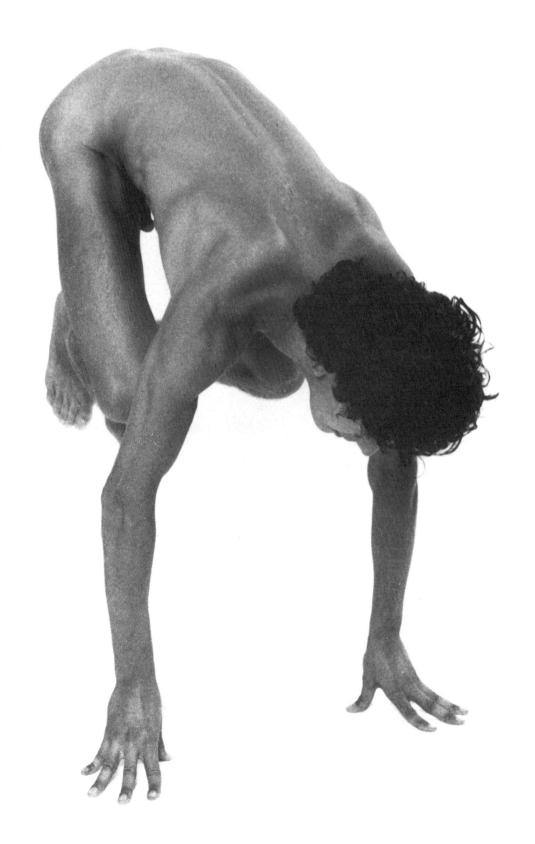

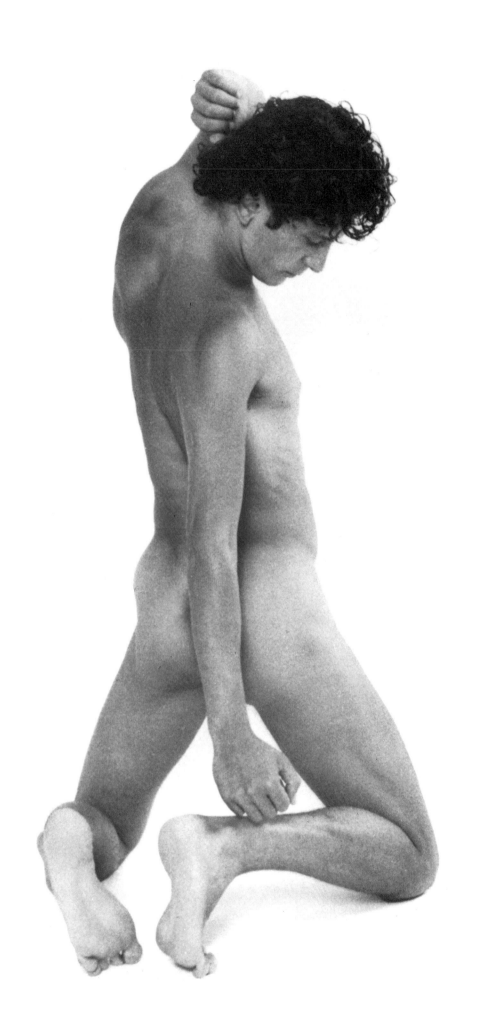

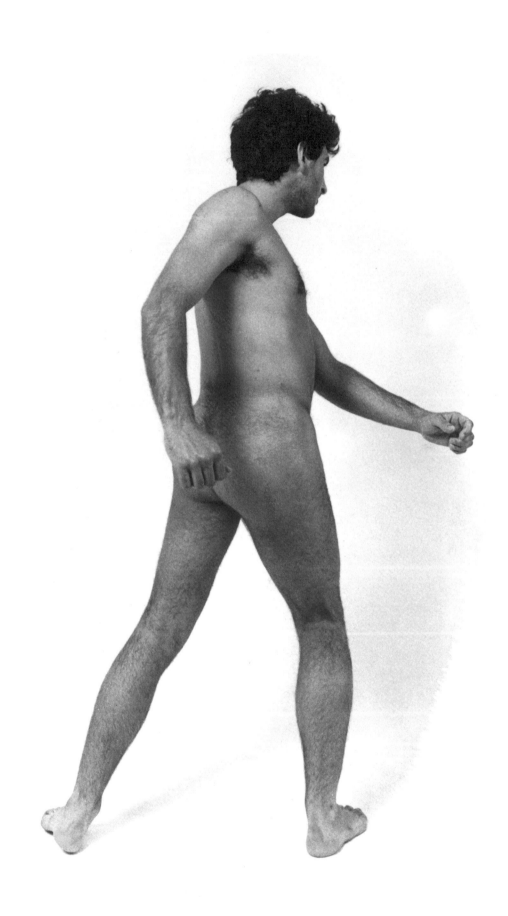

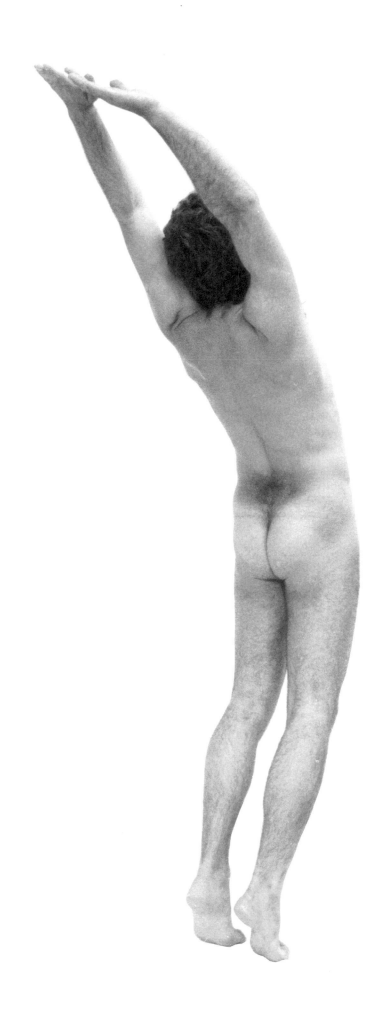

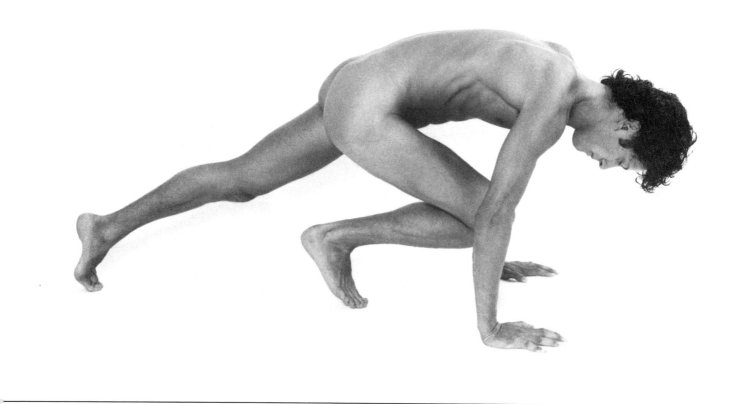

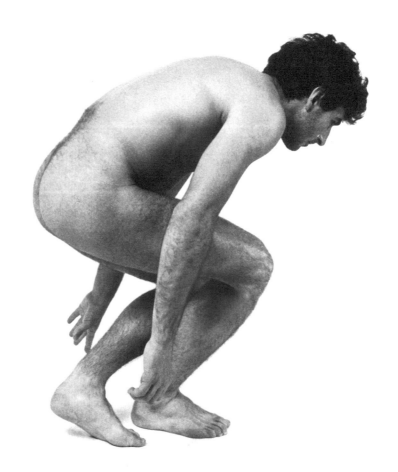

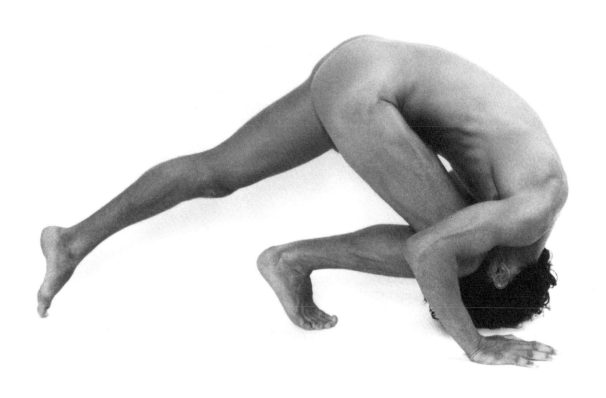

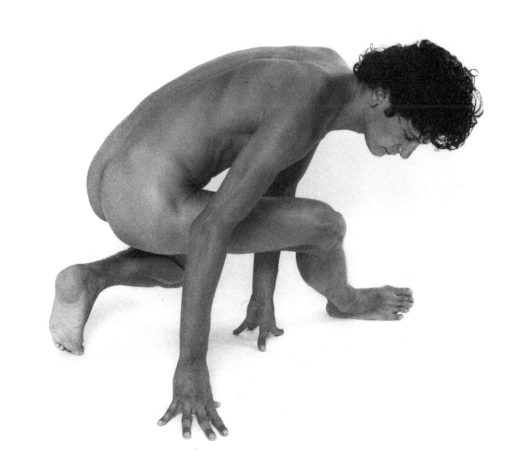

159

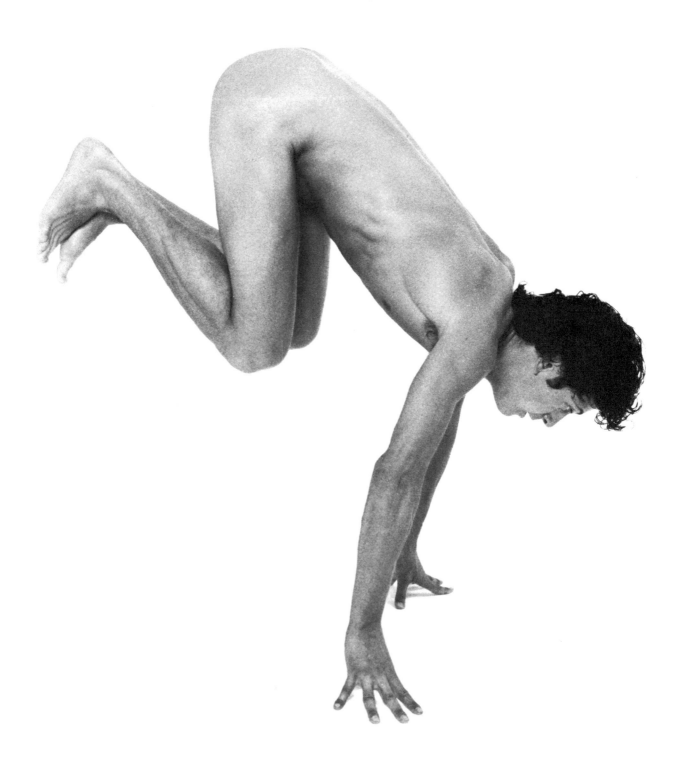

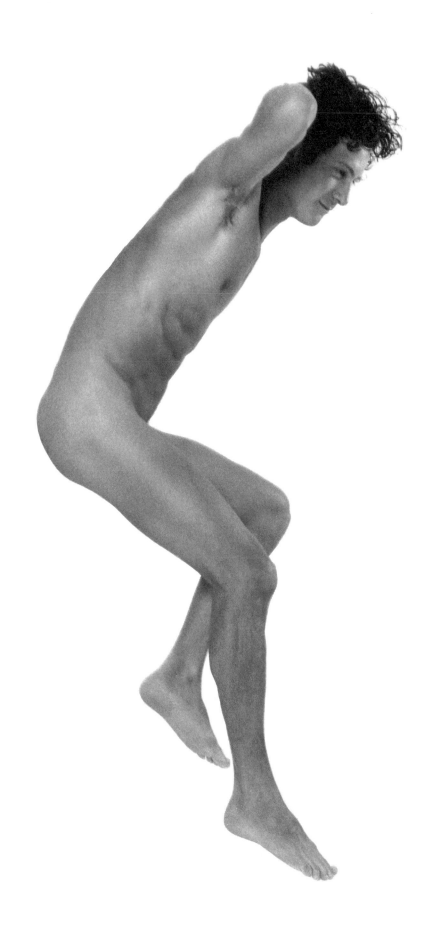

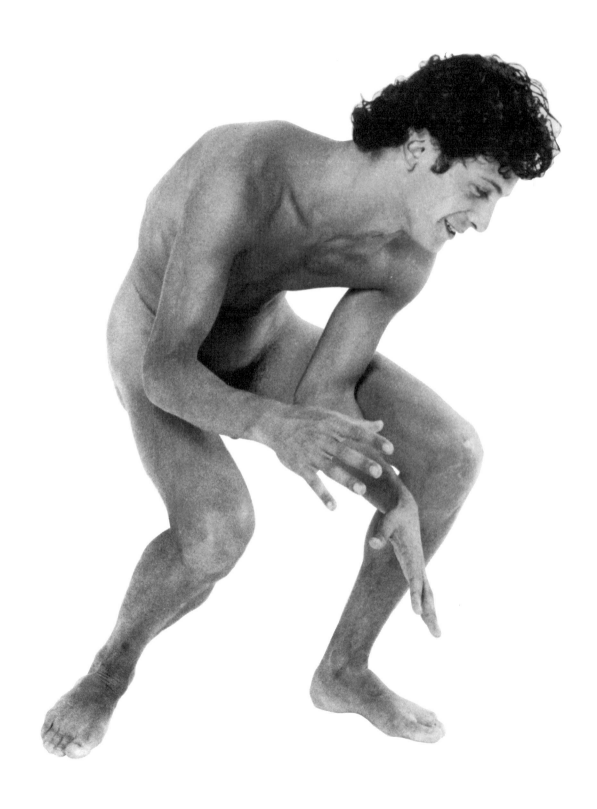

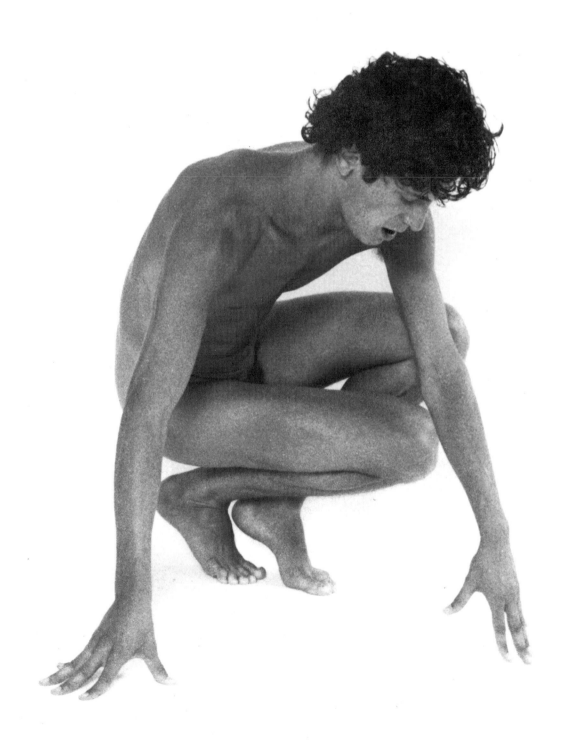

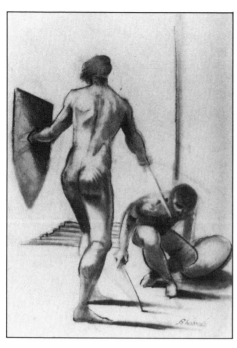

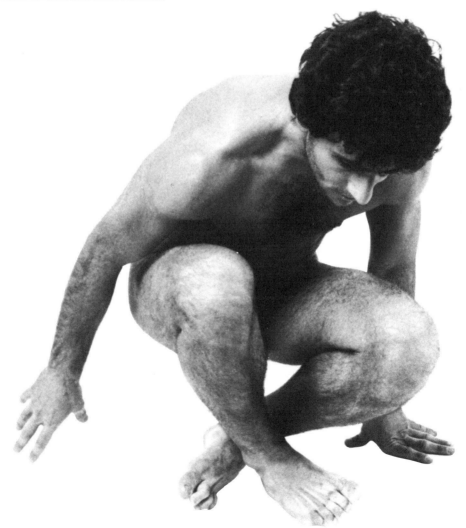

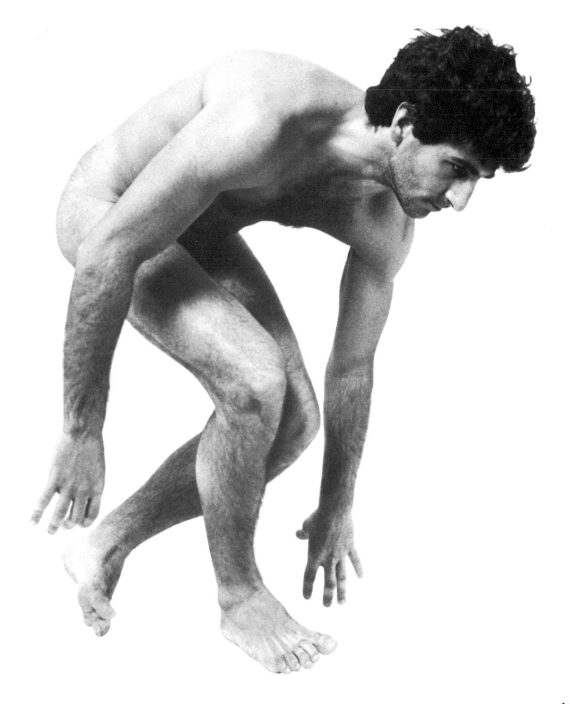

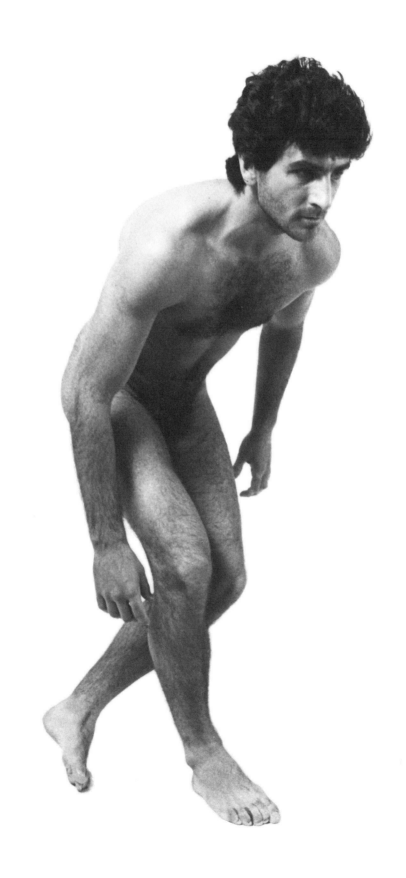

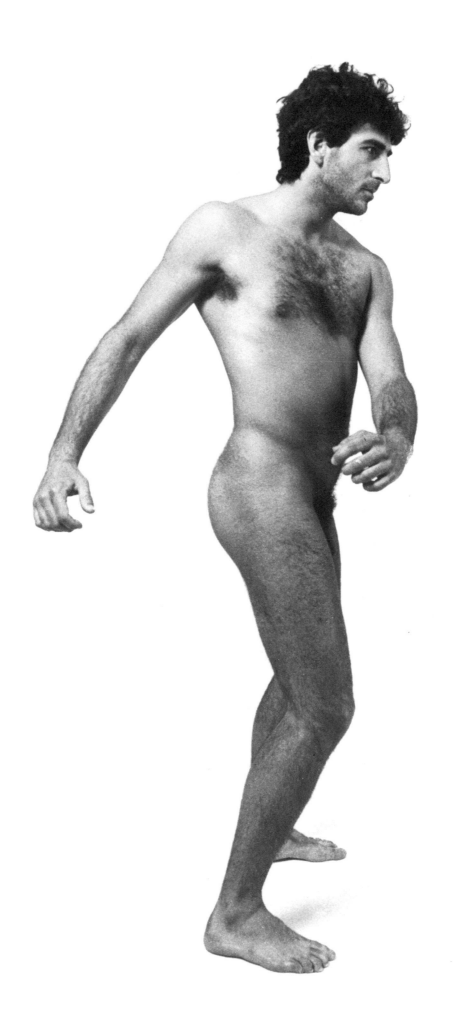

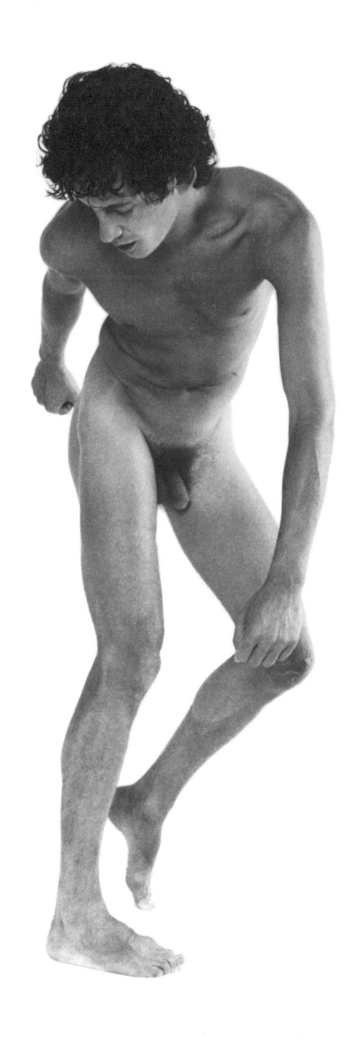

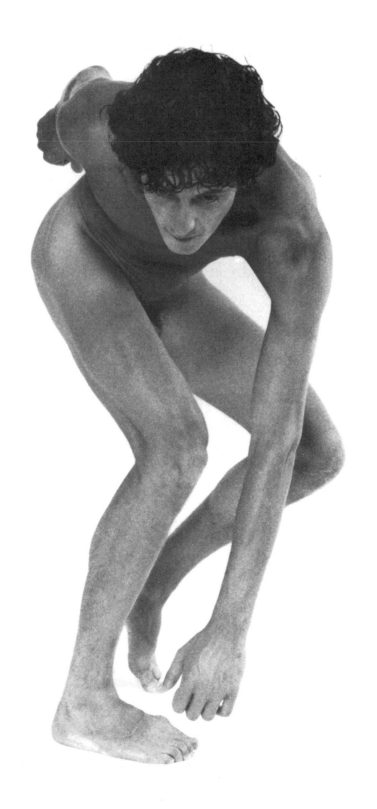

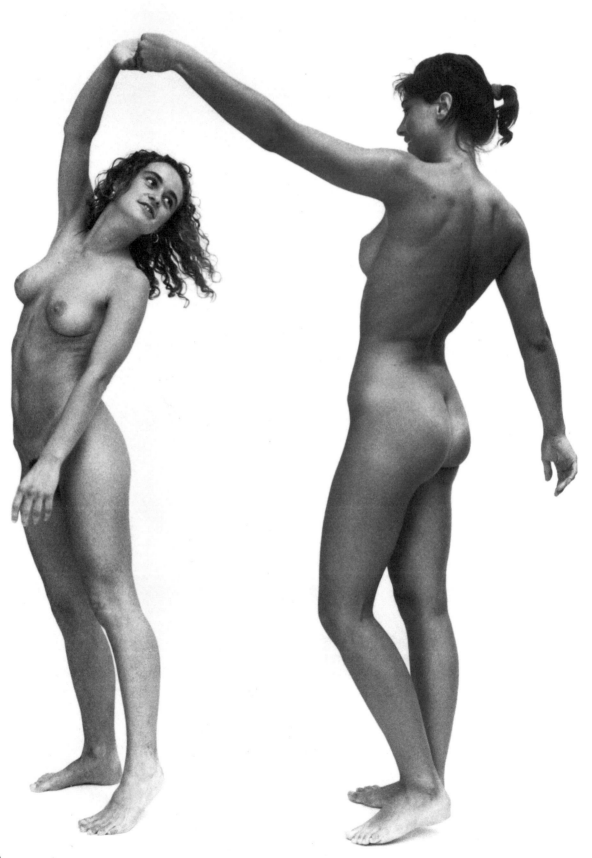

170

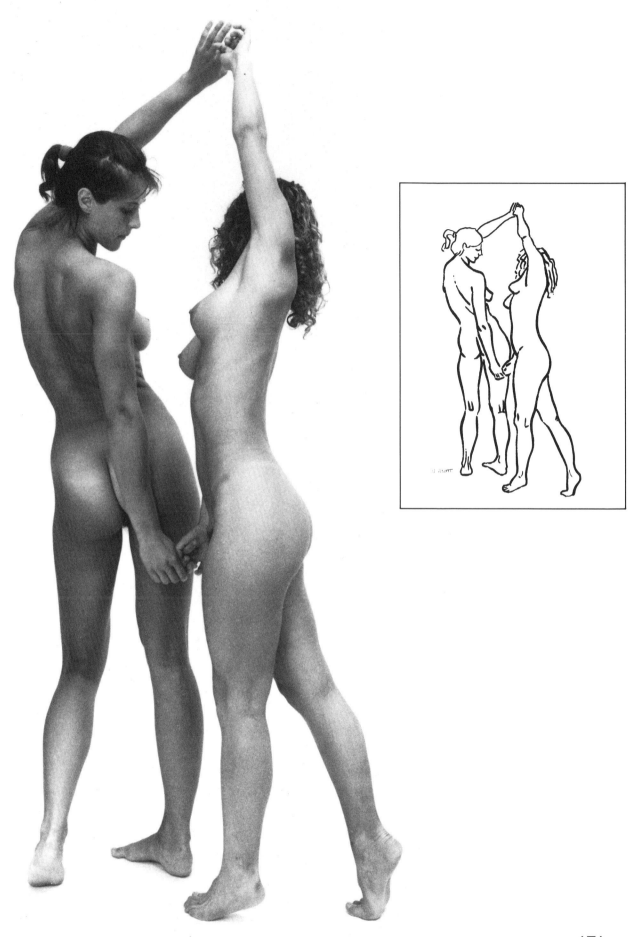

171

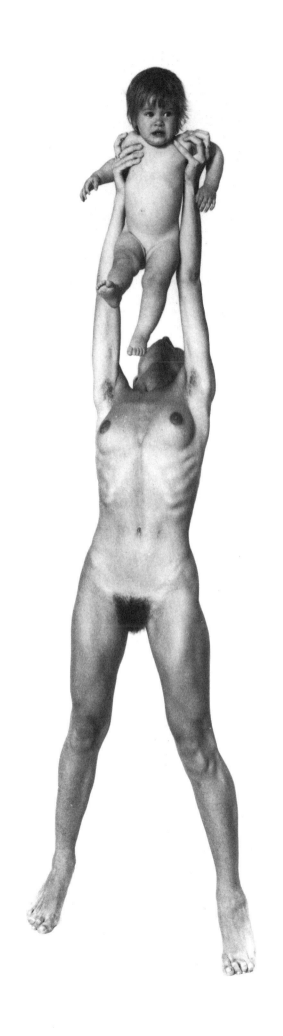

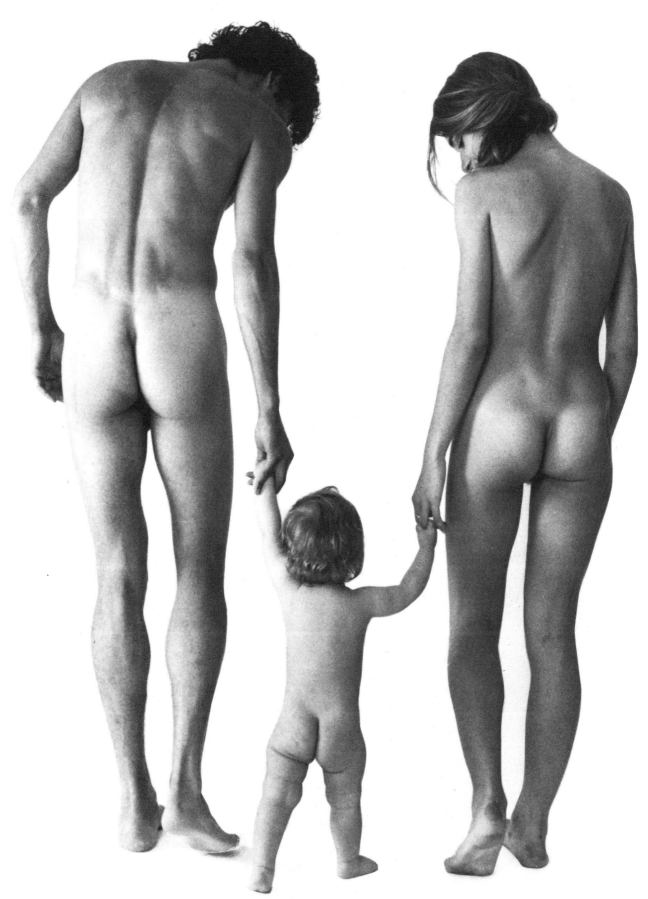

About the Contributing Artists

Geoffrey Humphries, a Briton, has lived in Venice for twenty years. He specializes in portraiture and figure drawings. Humphries is an artist of international reputation who exhibits annually in London and Venice. In his drawings we find a relaxed style and confidence and an ability to capture the often illusive feelings of the body. Humphries's drawings appear on pages 39, 51, 61, 86.

Auguste Haboush is a young American artist who lives in London. He comes from a family of artists and has succeeded in incorporating diverse styles in his work. He often experiments with new materials, forms, and ideas. Haboush recently became an animator for Walt Disney Studios. His drawings appear on pages 37, 87, 104, 114, 139, 148, 164.

Bob Morgan has an international reputation as a landscape painter and portraitist. Morgan is an American who lives in Venice. He has exhibited on both sides of the Atlantic, and his work is in many private collections around the world. Morgan's drawings appear on pages 12 and 62.

Wayne Mott, also a young American, is living and working in Paris. He has just begun his artistic career. Mott's drawings appear on pages 103 and 171.

The drawings that appear on pages 65, 89, and 120 are the work of author Thomas Easley.